this book belongs to:

thank you

to my family, for always supporting my love of art.

LORNA SCOBIE

Animal Art

101 creative activities to inspire and guide you

Hardie Grant

BOOKS

CONTENTS

LET'S MAKE Animal Art

Drawing animals has always been my passion, and in this book I share my tips and ideas in the hope that you'll love making animal art too. **Wildlife inspires me because there is such a variety of colour, pattern, texture, character and expression to explore.** I've designed 101 animal-themed activities to inspire, encourage and guide you to build a menagerie of creativity!

Being creative is a great way to take time for yourself. It can be an expression of joy, and what interests and excites you about the world. It can also help you to relax. I've always found that observing and drawing the animal kingdom can be very calming. We can study another creature and focus just on the here and now, taking time to consider how they feel and how they move. Sharing a moment of stillness with wildlife can be very grounding, and at other times, it is exhilarating to be energised by its wildness!

If, like me, you don't have access to a wide range of animals to draw, that's no problem. I've found ways to depict wild animals in my art even when I've not been able to see them in real life. There is a vast array of resources available, from videos of animals online, nature documentaries and live wildlife streams, to photographs in books and magazines. That said, **it's always surprising to discover how many animals are right on our doorstep**, and getting out into the wild – in parks, gardens, museums and wildlife parks – can be a great way to experience nature. And, of course, there is always your imagination – something I actively encourage you to use.

This book provides a space where you can focus, unwind and learn, as you expand your skills and understand more about how you *personally* like to create. **Fill these pages in a way that is interesting to you – this may mean you'd like to adapt the activities, and that is great!**

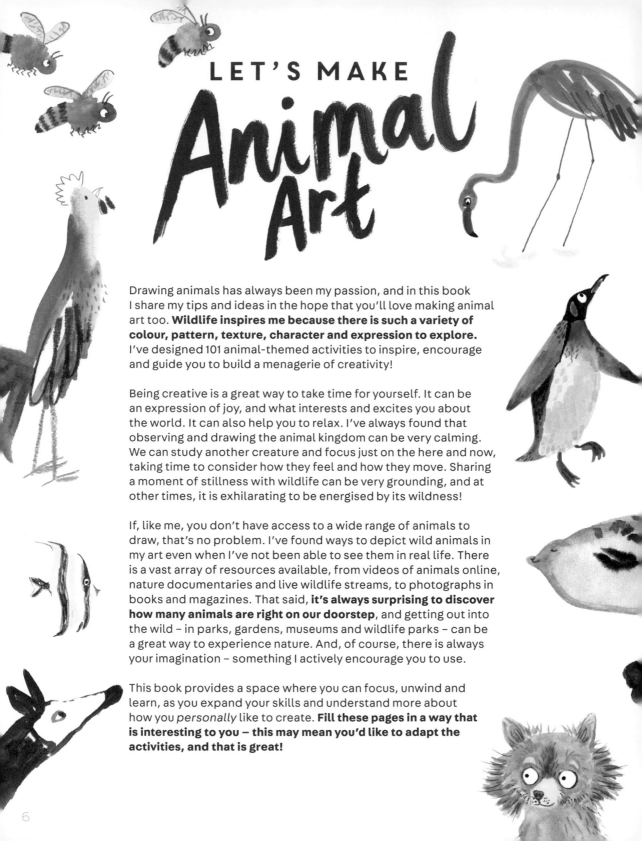

Use this book as your personal sketchbook and add notes, ideas, doodles and sketches to the pages. I encourage you to push yourself out of your comfort zone – try different art materials, draw animals that you haven't drawn before, and experiment with new styles and techniques.

The chapters or activities don't need to be completed in any particular order, just choose any task that sparks an idea, or suits your mood at that moment. There are warm-up activities at the beginning of each chapter to encourage you to let go of any inhibitions you might have about making a mark (and a mess!). Approach these with confidence!

This book is for everyone – all abilities and ages. I've added some tips to guide you through the activities, and have often provided an example or started off the activity for you, as I know a blank page can be daunting. Your art absolutely doesn't need to look like mine, just work in a way that feels natural to you. I encourage you to have fun, let go, and embrace mistakes as happy accidents – you can turn smudges into animals and stray lines into backgrounds or expressions of movement.

Perhaps this book will change the way you look at the animal kingdom, so that every creature you see has the potential to become a subject in your art.

Create animal art that you love and share it with pride!
If you feel like sharing your creative journey online, tag your posts **#AnimalArt101**.

MATERIALS

As with all elements of how you approach your art, there are no 'wrong' ways to use art materials – it's just a case of discovering what works for you. I encourage you to explore using different materials together in one artwork, and to be experimental. You can absolutely use what you already have, and what you enjoy using, but I've also suggested a few materials below in case you'd like to expand your art kit or try something new. I recommend visiting art stores to try out the tester materials before you buy – you might just want to add a few individual colours to your collection rather than buying a full set.

If you are using very wet paints or inky pens, I would recommend preparing the paper in this book before you start making art. Painting a layer of clear gesso onto the paper and allowing it to dry beforehand will provide a barrier and will prevent any paint bleeding through the pages.

colouring pencils

These are great for using wherever you are as they are lightweight and not messy. Some colouring pencils can be used with water to create a painterly effect. You'll need a pencil sharpener too.

pencils

There are different grades of pencil to choose from. H stands for 'hardness', B for 'blackness' and F for 'fine'. B pencils are soft, dark and easier to smudge and blend than H pencils, which are hard and produce crisp lines. I like to use mechanical pencils as they feel like pens to hold, but use what feels right for you. You might need a good eraser too – although I would encourage you not to use it too much.

drawing pens

Fine liner pens are really useful when you feel like drawing in one tone and for adding details. It is handy to have a few black ones of varying sizes, but they are also available in colours. I like them for drawing eyes.

brush-tip pens

These come in fantastic colours and can be great tools to make art with. Some come double sided, with a different-style nib at each end. They are useful for colouring big areas and creating bold shapes and marks.

paints

There are lots of different paints available, and for this book I recommend using acrylics, gouache or watercolours, as they are water based and so are easy to clean up and dry quite quickly on the page. Mixing palettes are very useful so you can mix your own colours, and then clean them with water once finished.

wax pastels

These are a fun and slightly messy material and you can use them like a pencil or on their sides to cover large areas. They have a lovely texture and there is a wide range of colours, which can be bought individually or in sets. You can buy grips to stop your hands getting too messy! Drawings in pastels will transfer on to the page opposite, so either spray your finished art with a fixative or tape a sheet of tracing paper over the top.

paintbrushes

These come in a huge variety of styles, shapes and sizes. It's useful to have a very small brush for fine details, and broader ones too for quickly covering large areas in colour. You will also need a cup or jar of water to wash your brush between colours, and to water down paints. When using watercolours, I really like using water brushes, which can be refilled with water. This means you don't need extra water. For all paints, make sure you have some kitchen roll or a sponge handy – for blotting excess water and cleaning your brush.

coloured paper

You could start a collection of coloured or patterned paper to use within your art. You'll also need scissors, and a glue stick or PVA glue. You can also create your own coloured paper for collage, by painting sheets of paper in the colours of your choice, and leaving them to dry.

PETS

Let's start with a warm-up activity to get your creativity flowing. Draw as many pets as you can – real or imaginary!

There are no rules! Just go for it, and have fun.

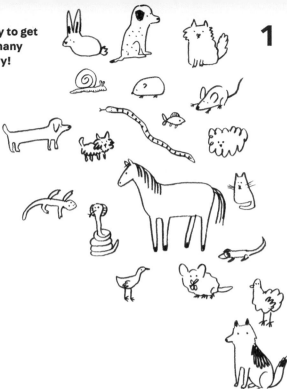

Sweeping brush marks can be turned into moving dogs.

Use your imagination to **change these painted brush marks into dogs,** and then **create more dynamic dogs** by making your own quick, sweeping strokes. Add heads, legs and tails to your dogs.

TIP *Focus on showing energy and movement, rather than worrying if your drawings look realistic.*

Enjoy filling the page with rabbits!

Rabbits, with their big round bodies and long ears, are made up of really fun shapes that you can exaggerate. Add little details too, such as tails, faces and whiskers.

Don't worry about how the whole image will look, just add rabbits one by one, exploring a variety of shapes, colours and poses.

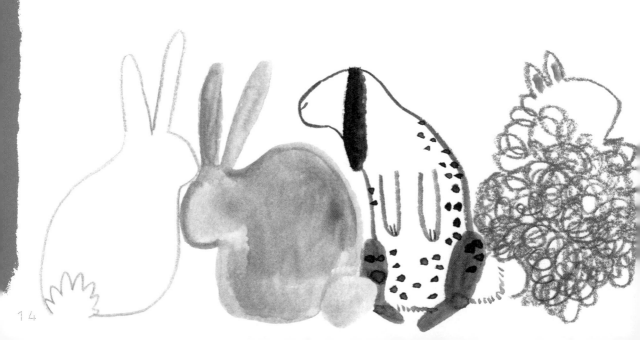

Take the opportunity to draw a sleeping cat when you can.
They make a great subject to draw as they stay still for a while.

First, choose a palette of colours to use in the drawing, and then sketch out what you see roughly in pencil.

Then add colour. To create a drawing with a loose, relaxed feel, concentrate on adding colour and tone rather than on details like individual hairs. You could use more vibrant colours than you can actually see, to give the image a dream-like quality.

TIP *If the cat walks off, that's alright! Leaving part of your image unfinished can actually make it feel full of life.*

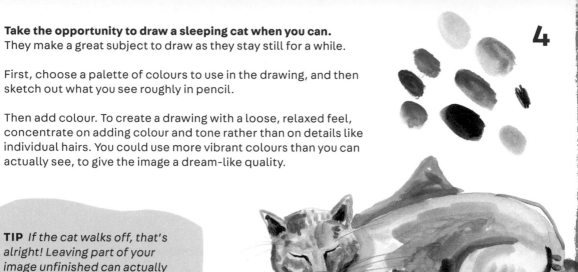

Design some dogs. Explore pattern, texture and colour.
They could be cartoons, or realistic – use any style you like.

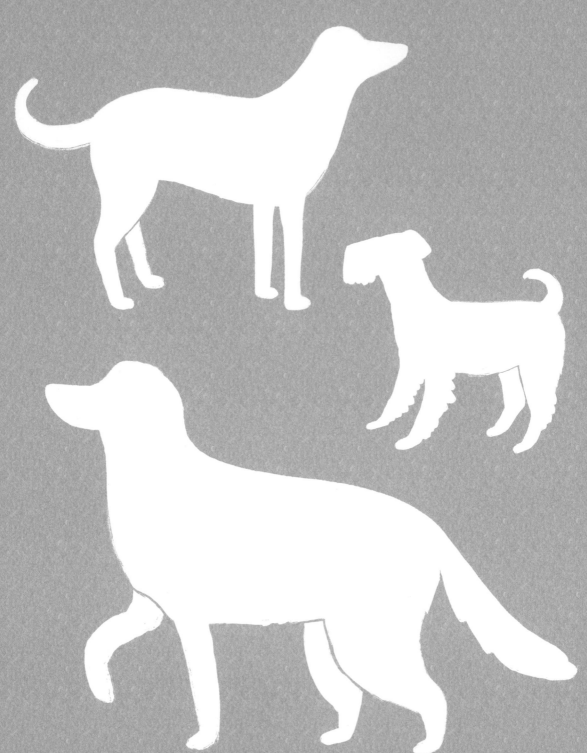

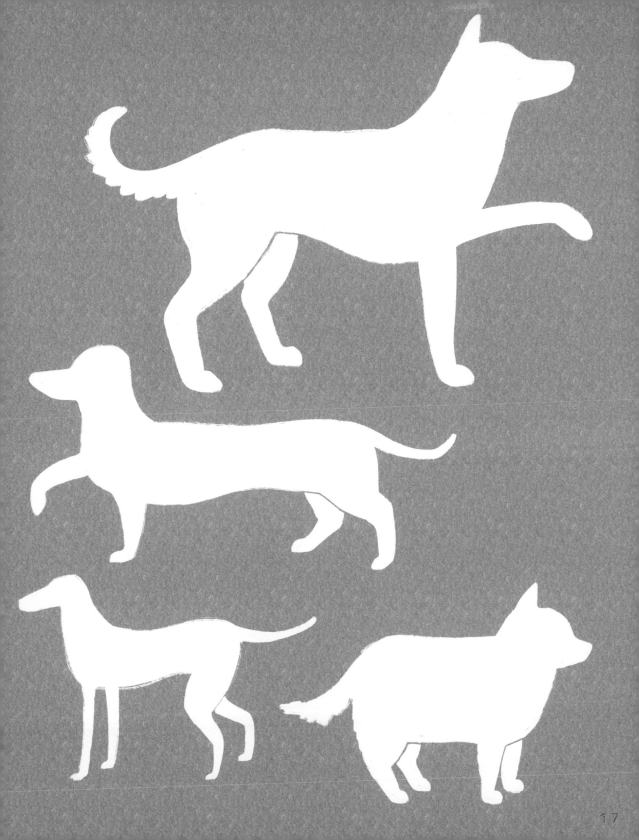

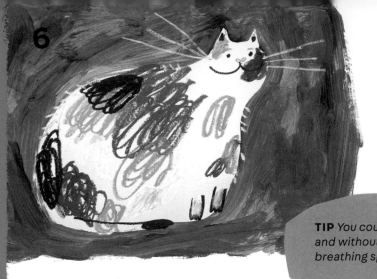

6

Create a painting or drawing of a pet by first filling in the background so you're left with a shape that is your 'negative space'.

Colour the background so you are left with the white shape of your pet on the paper, then add features to complete your image.

TIP *You could leave some of the paper white, and without details. This can give your art breathing space and a sense of energy.*

Draw a pet in its home environment. Perhaps a fish in an aquarium, or a reptile in a terrarium.

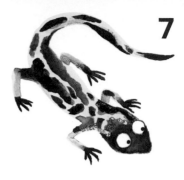

Find a photo of a pet and re-draw it. Drawing from a photograph of a pet means you can spend a lot more time studying the details as you don't have to worry about them running off!

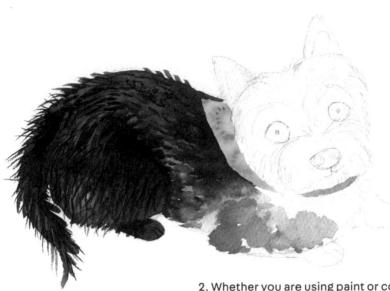

1. You could start by drawing the outlines of your pet, to create a pencil sketch.

2. Whether you are using paint or coloured pencils, consider first adding the lightest colours you can see on your animal.

3. Next add the medium tones. You could add colour in blocks, or in strokes to look like hairs.

TIP *Squinting at your photograph can help identify the different tones in the image.*

TIP *Before drawing the hairs onto your artwork, consider which direction they are pointing.*

4. Finally add the darkest colours you see in the photograph. These might be areas of shadow, the features of the face, and individual hairs across the body.

You could use a fine brush or pencil for these details.

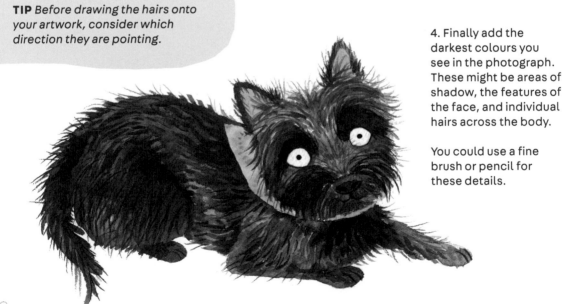

9

Fill the grid with lizards and other reptiles. Consider how you can use the limited space to explore the shape and form of the animals. Focus on using striking colours and graphic shapes.

You could do close-ups too – the head of a crocodile or snake with its mouth open, say.

Turn these little splodges into little critters. Mice, hamsters, gerbils and other rodents have similar body forms and you can make them distinctive by adding features and expressions.

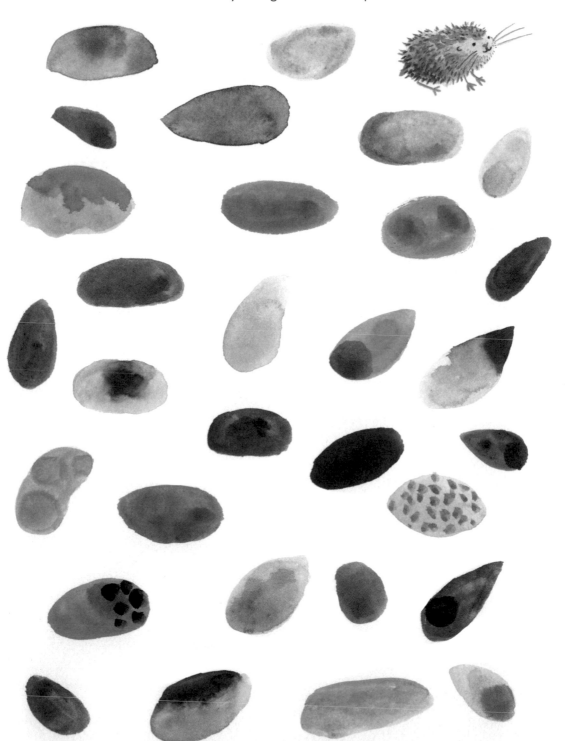

Draw moving pets from life.

This can be a fun challenge. Try using materials that you can move quickly across the page – perhaps a pencil or an ink pen – so that you can draw as much of the animal as possible while it moves.

Work quickly, and don't worry about continuing with the same drawing once the pet has changed pose. Just draw what you manage to observe, before moving on to the next drawing. Your drawings may overlap and intertwine, which adds to the feeling of movement.

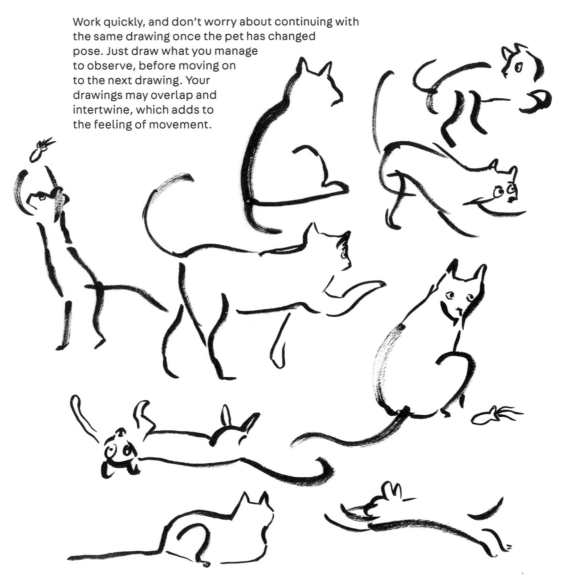

TIP *Rather than drawing every outline, consider simply drawing single lines for the limbs of the pet. That way, you can quickly get a sense of the position they are in, and get as much information onto the page before they move again.*

12

Despite their small size and relatively simple shape, guinea pigs can have loads of personality.

Practise drawing guinea pigs by keeping their bodies simple, adding legs and a face and, most importantly, an expression. You could draw long-haired guinea pigs too.

Draw lots of different dog faces, real breeds or imaginary.

There are so many different types of dog and it can be fun to explore the variety in your art. Consider the length of the snout, the position of the ears, and the colouring.

14

Draw a pet from real life to capture as much of their personality as possible.

You can also make drawings from videos of pets. These methods can be better than photos for getting a good sense of the pet's personality. You can see how they move around the world and how they react to it.

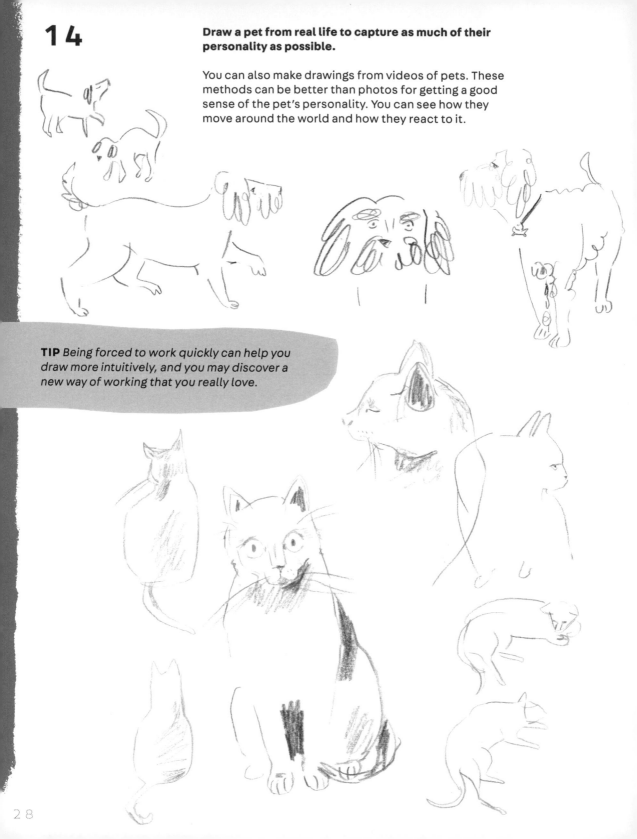

TIP *Being forced to work quickly can help you draw more intuitively, and you may discover a new way of working that you really love.*

15

Create some finger blob pets!

Add features to these coloured blobs to turn them into dogs,
frogs, rabbits and any other pets you 'see' in the shapes.

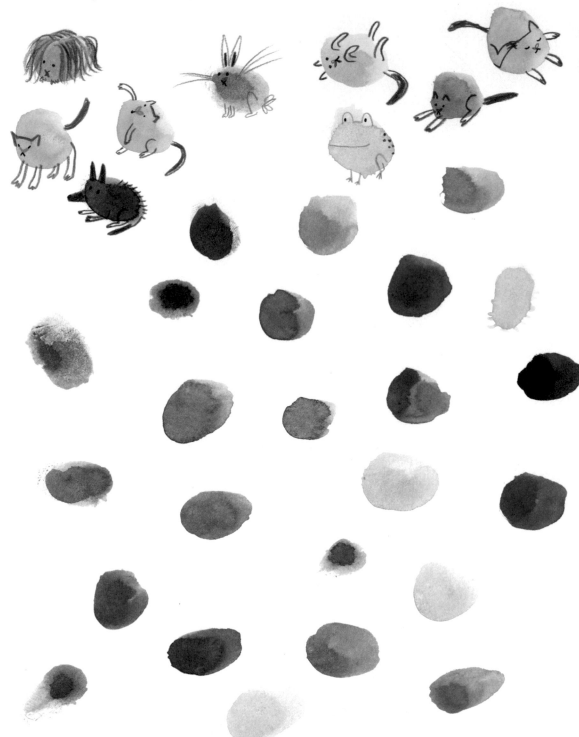

Here's a chance to get messy! Make your own blobs.

Create blobs of colour using watercolour or watered-down acrylic paint. You could dip your fingertips into the paint to create prints or just use a paintbrush. Then add features to your animals

16

Create some art based on a tortoise or turtle. You may be inspired to focus on the shell, and explore its bold patterns, or perhaps you are drawn to experimenting with colour, and the textures you can make with your materials.

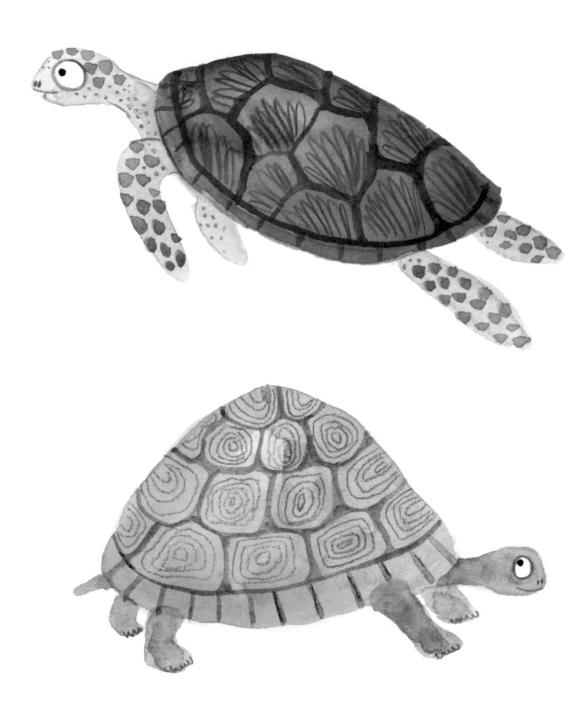

17 There are lots of ways to depict fur on your animal drawings.
**Explore using different materials to create the look of fur,
then add fur to the cat shapes.**

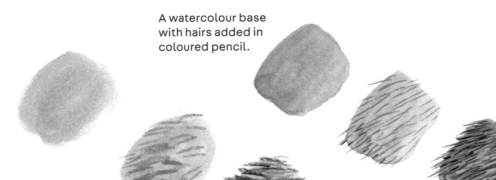

A watercolour base
with hairs added in
coloured pencil.

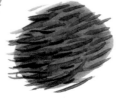

A brush-tip pen base,
with hairs added using
pastels, for a rougher,
textured feel.

A pen base with pen hairs
added in a sweeping motion,
for a more graphic feel.

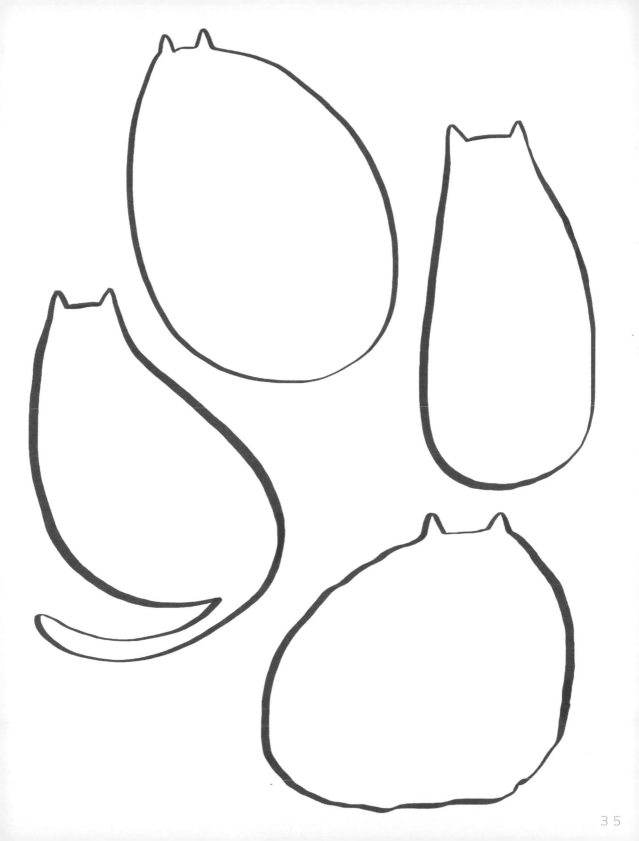

SEALIFE

Turn these colours into a shoal of fish in any way that inspires you. You may feel like using collage, adding details in pen or adding outlines to the colours. Or perhaps you will go for something very abstract.

As always, there is no right or wrong approach – this is a chance to explore and be playful.

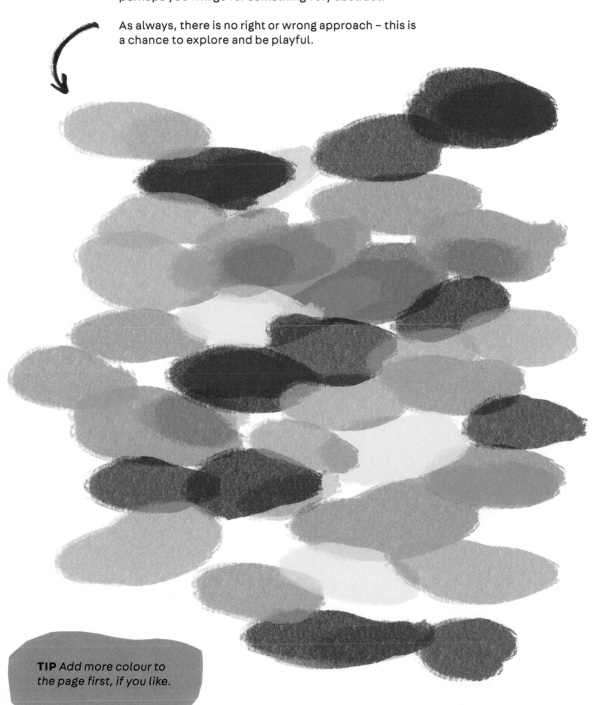

TIP *Add more colour to the page first, if you like.*

Add colour and texture to these whales. Experiment with using your materials in a way that suggests liquid, or light shimmering and reflecting underwater.

There is space to add your own whales in too.

TIP *You could let watercolours bleed into each other and, once dry, add marks and details using white pastel or pencil.*

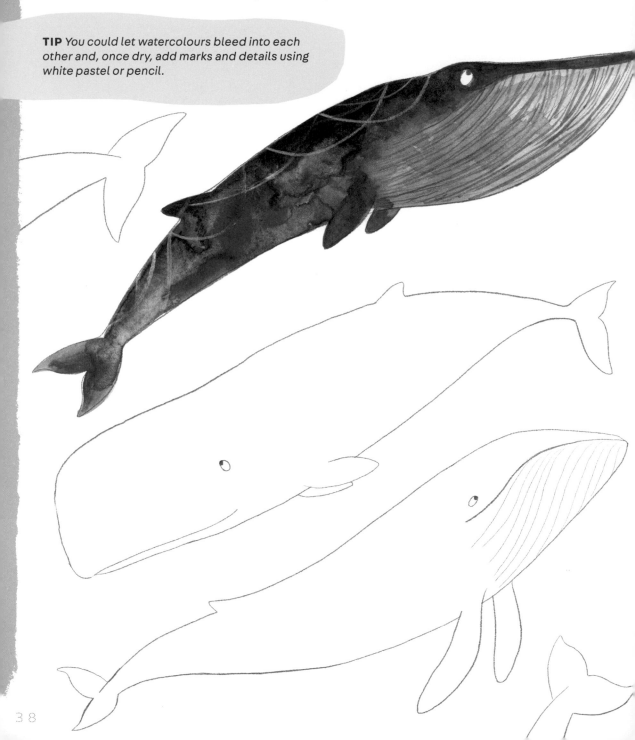

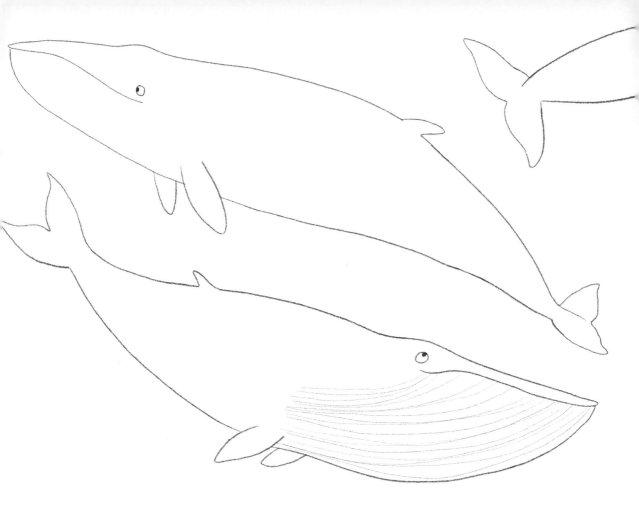

Make a piece of art based on a coral reef, observed from life.
Try to capture the motion and energy of the living ecosystem.

Although it's unlikely you'll visit a reef and make a drawing in person, there are lots of ways we can see how life on a coral reef looks and moves.

If you have the opportunity, you could visit an aquarium, and you can also see videos of live coral reefs if you search online. These are fantastic as you get a really great sense of what it's like to be in the reef among the fish, and you can practise drawing them as they move about naturally.

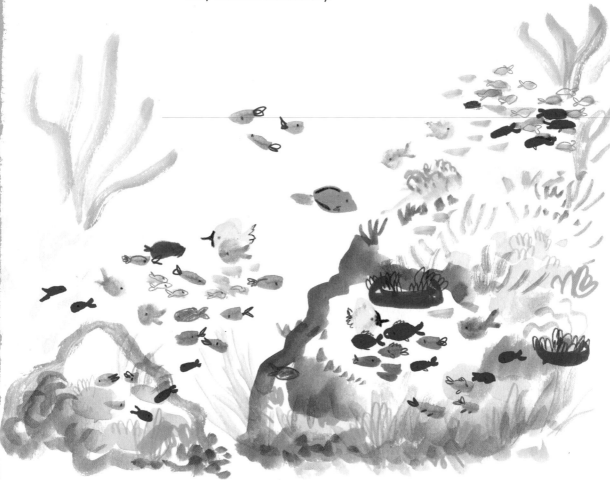

TIP *You may not be able to capture a lot of fine detail as everything is usually in motion, so just draw what you can, and enjoy the process. You could focus on adding the colours that you see, quickly painting colourful fish in a simple style, before they swim off.*

Create starfish.
You could spend time
drawing their intricate
details and patterns
or exploring their bold
graphic shapes.

Draw a lobster or crayfish in four different ways. They have complex shapes. You could draw their outlines with a loose pen, or use colour, make them abstract . . . anything you like.

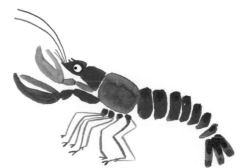

Draw lots of seahorses. Seahorses have got such an unusual shape that at first, it can be tricky to draw them. Try simplifying their bodies into basic outlines, to help you understand their form.

TIP *You could use a coloured pen to draw the bodies of the seahorses – it means you can make quick, fluid marks. Paint could produce some exciting shapes too, especially if you play with how much pressure you are putting on the brush as you move it, creating a tapered edge or thick one.*

Jellyfish are fascinating to draw as unlike a lot of animals
. . . they are translucent!

Explore making art inspired by jellyfish.
You could use thin layers of watercolour to create an
ethereal look, or even create a collage from tissue paper.
Be bold and experimental.

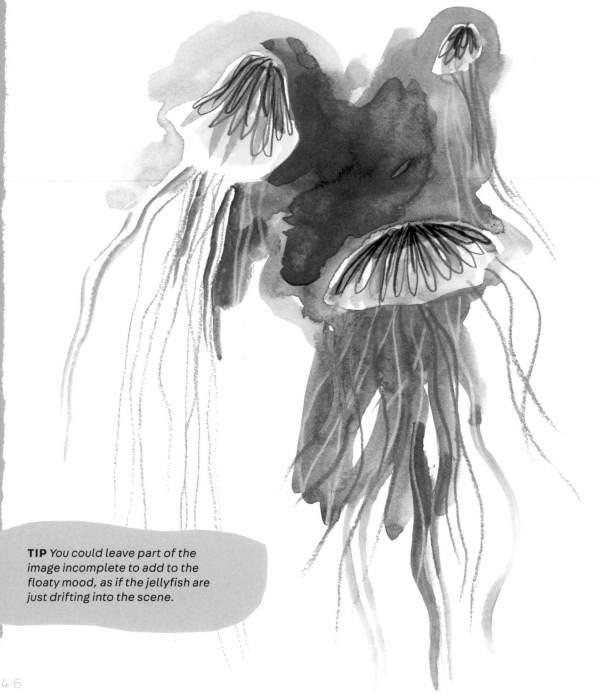

TIP *You could leave part of the
image incomplete to add to the
floaty mood, as if the jellyfish are
just drifting into the scene.*

Draw a pod of dolphins jumping out of the water.
You could think about ways to show movement in your
art – perhaps there is water *whooshing* off their bodies
as they leap from the sea?

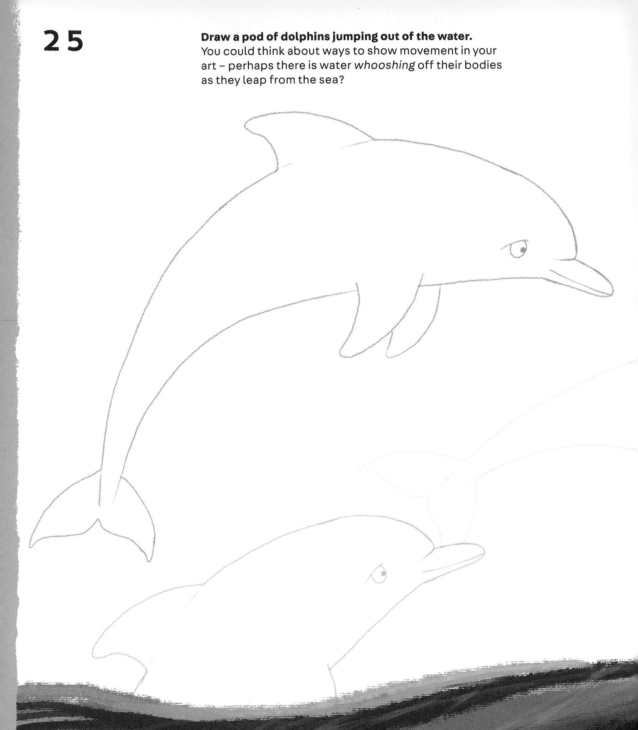

Draw lots of different shapes of fish.
Consider the variety under water, whether that might be size or shape.
You could add large sharks with unusual forms, like hammerheads.

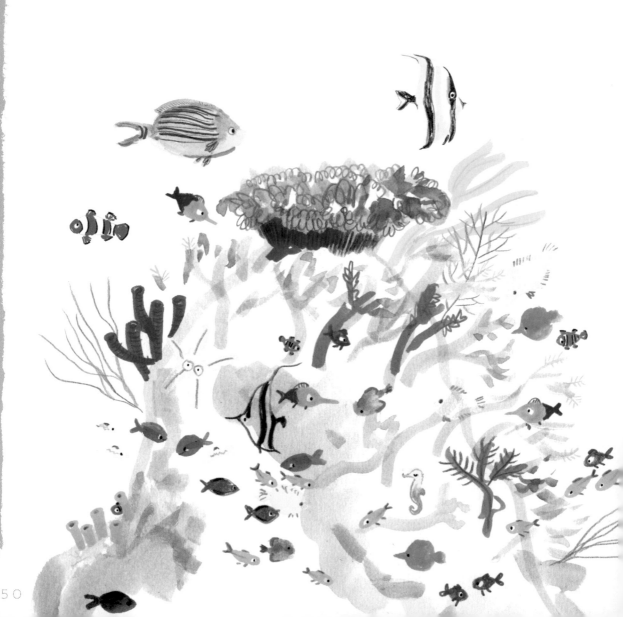

Not everything under the sea is brightly coloured, and you can create striking art using just black, grey and white – a monochrome palette.

Draw some orca using any materials you like, but limiting your palette to monochrome. You could use the paper to create your areas of white. You may find it useful to sketch your orca shapes first using pencil.

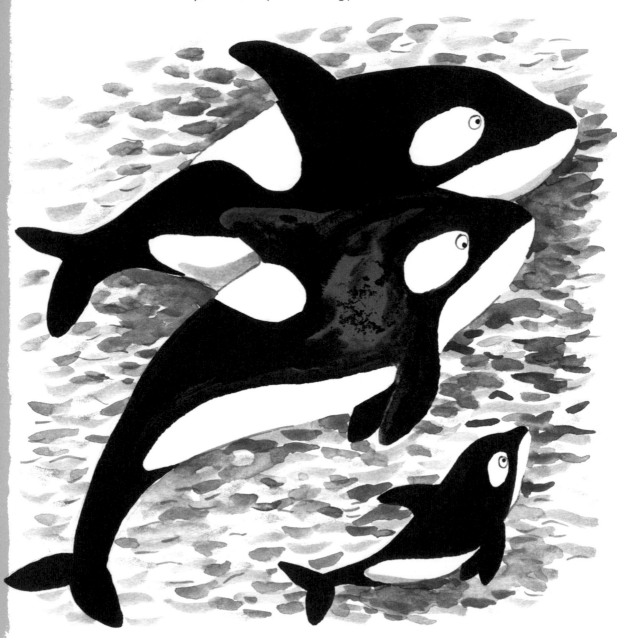

FARM

Warm up by drawing some farm animals, simply in bright colours. There is no need to make them realistic – instead, enjoy the forms of the animals and the opportunity to try out colours you enjoy.

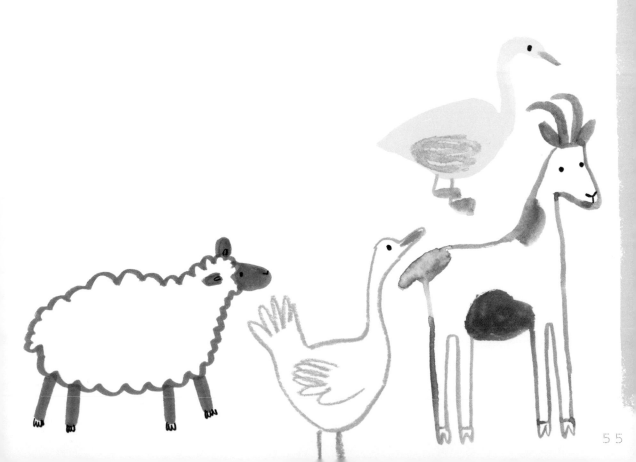

29 **Draw a herd of cattle using these colours and shapes as inspiration.** Your art could be abstract, or realistic. You could begin by drawing outlines, then adding tone and more colour – or perhaps create a more graphic design using outlines alone.

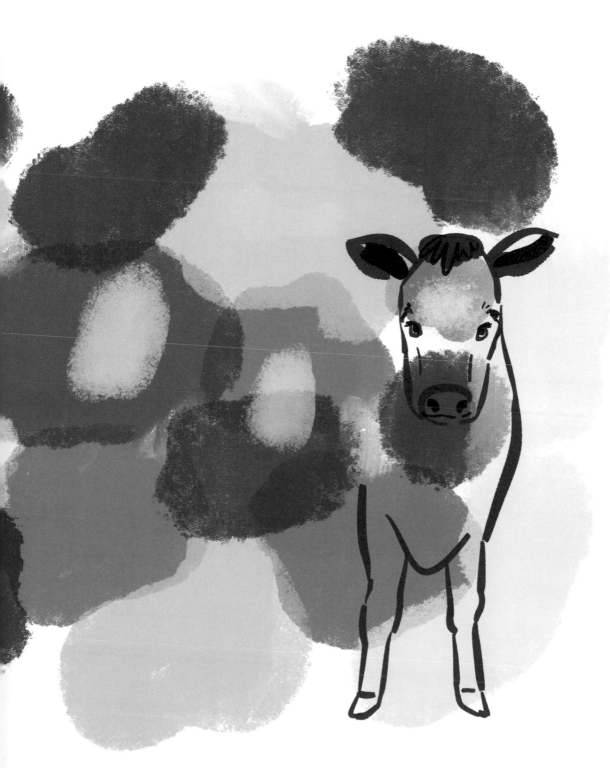

Draw some chickens! Use the shapes as starting points, then draw some more from scratch.

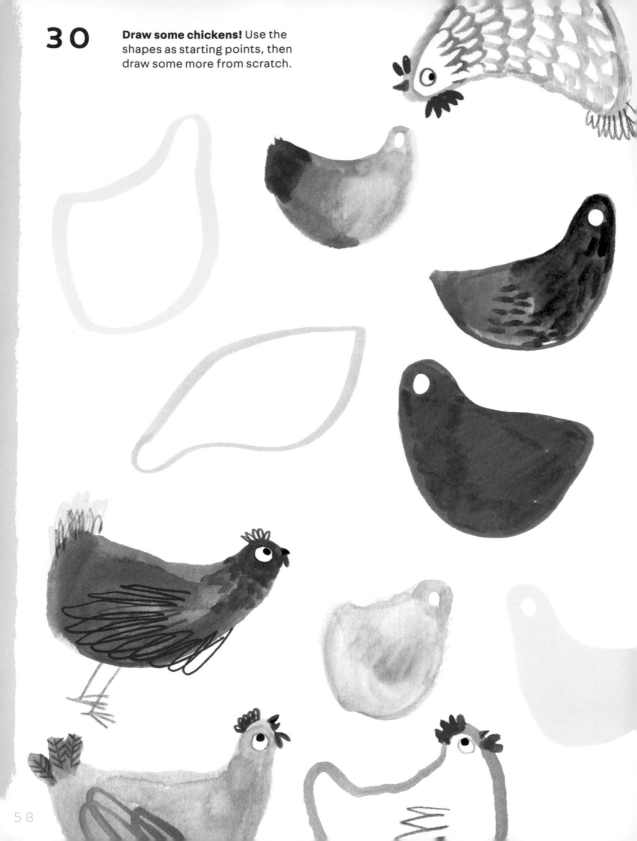

31 **Practise drawing horses.** It can seem challenging to draw horses, but breaking them down into their basic shapes can really help.

Start by drawing them as lines and rectangles, from pictures. Notice how their legs bend, and how big their head is in relation to their body.

As you get more confident with drawing a horse's form simply, you could try adding to your shapes, fleshing them out and adding colour, hair, perhaps tone too . . .

Or you could draw horses from imagination, and enjoy any 'mistakes' or quirks. This could bring some fun personality to your drawings!

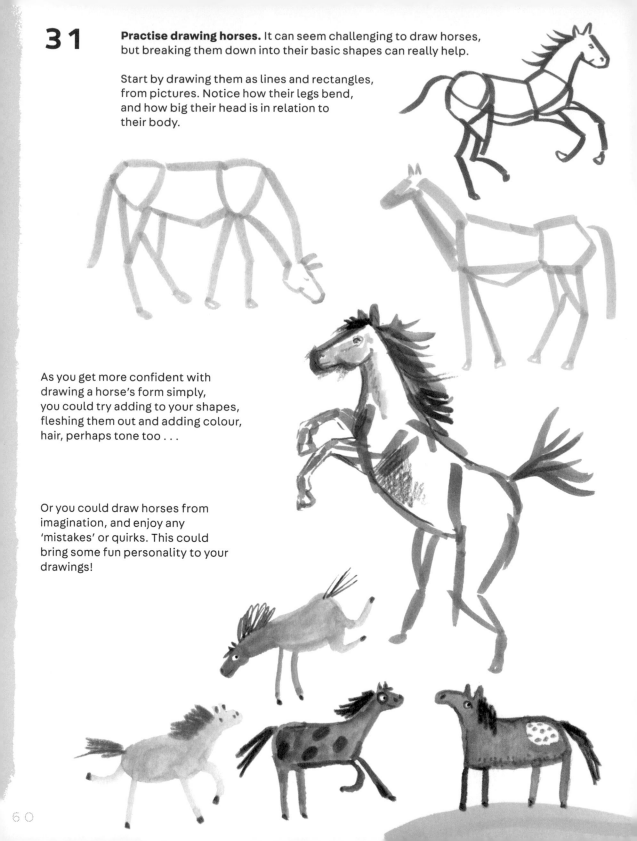

Ducks make fantastic subjects because their forms are relatively simple and there is so much variation in appearance between species.

Create artwork inspired by ducks. You could use collage – creating cut-out paper shapes for the ducks. Consider the composition on the page, perhaps thinking about how the shapes can interlock with each other. Or just go wild!

TIP *If you're collaging, there is no need to draw your shape before you cut the paper. Use the scissors to 'draw' instead - it can be liberating!*

TIP *Perhaps the leftover paper will inspire you to create more art!*

Make some sheep!

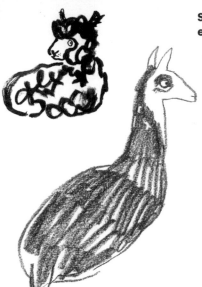

They can be fun to draw, as you can exaggerate their fluffiness and their funny expressions.

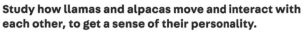

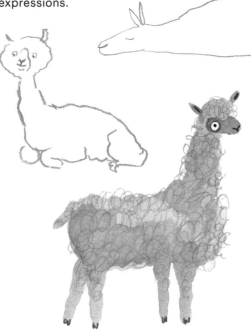

You can use what you know about the character of an animal to inspire the way you draw them. Drawing cockerels offers a chance to explore capturing an energy and pomposity in your art.

Have a go at drawing cockerels.

Imagine some strutting around a yard. Their form can be captured quite simply – with just a few sweeps of a brush. Use quick movements. Perhaps employ a variety of art materials to add texture to their feathers.

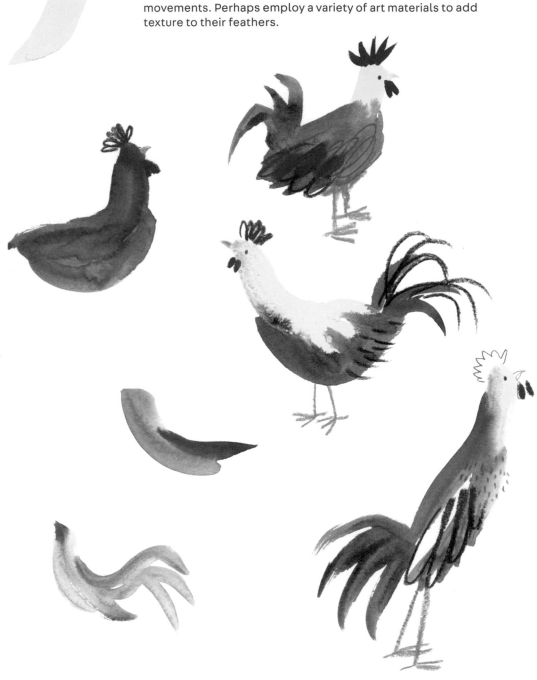

36

Add animals to these fields. You could also add more trees, hedges, fences, or perhaps some birds in the sky.

37 **Draw baby farm animals.**

Observe how young animals look and move, thinking about what specifically makes them look young. They often have long, unsteady limbs, downy feathers and large eyes.

1. Quickly draw some blobs or shapes. Drawing fast means the forms will naturally have energy – just like a baby animal might.

2. Add some simple features. Consider putting the eyes low down on the head to give the appearance of a big forehead. Depending on which animals you choose, you can add noses, ears and legs.

3. Finally, add a few stray feathers or hairs to suggest scruffiness!

WILDLIFE

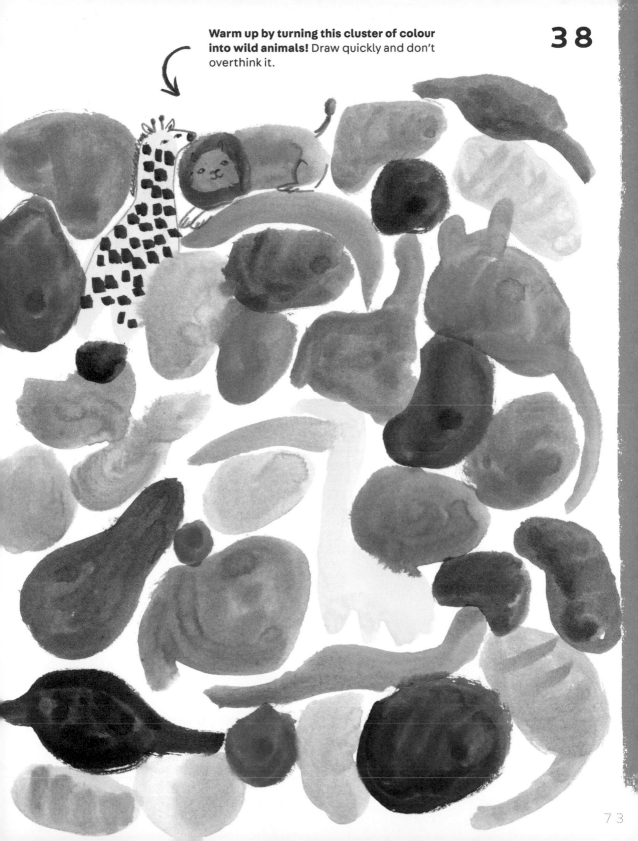

Warm up by turning this cluster of colour into wild animals! Draw quickly and don't overthink it.

Making animal art provides a great opportunity to have fun with pattern. **Use this tiger outline as your canvas and enjoy adding patterns to its body.** Use any materials you like. Perhaps you could add the jungle around it, or an abstract pattern to represent its habitat.

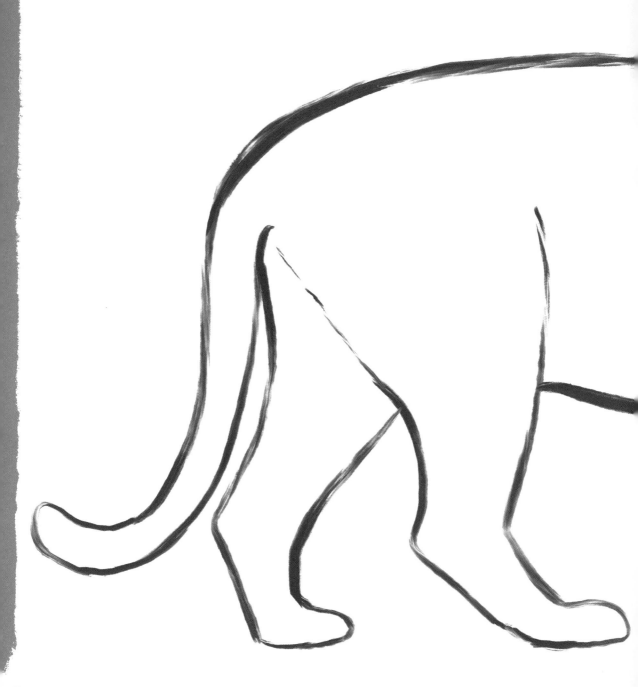

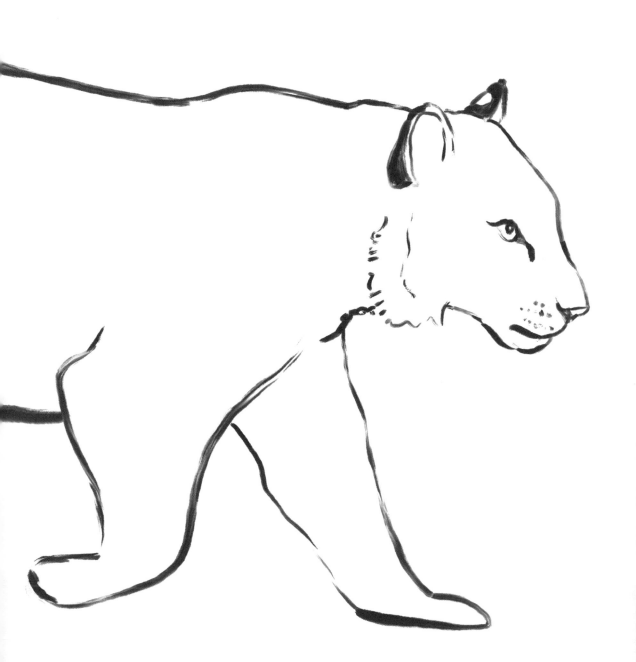

Draw animals from life. Perhaps you could visit a zoo, or look at animals in a park or woodland.

TIP *You could take a sketchbook and fill the pages with lots of quick drawings. If you aren't happy with your drawing – no problem – just turn the page!*

TIP *Taking time to study animals from life can improve our understanding of how they look. Draw the same animals from multiple angles, to help learn about their form as they move about.*

41 Draw an animal with lots of fur.

You could build up your image gradually, starting with a base layer in a few flat colours, then add tone, and then use coloured pencils to add lots and lots of hairs.

TIP *Consider the direction of the hairs and curvature of the body when you are adding individual hairs.*

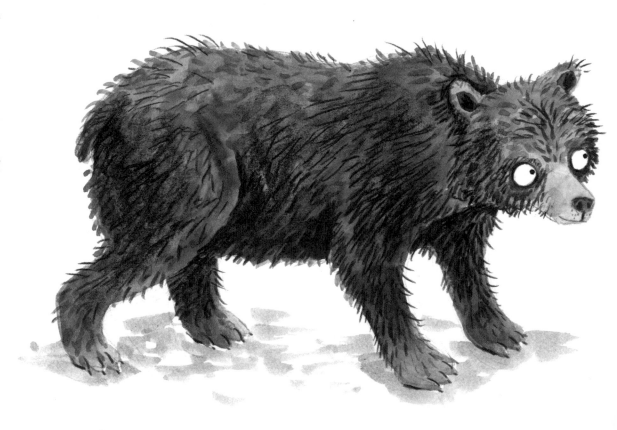

42 **Draw your favourite animal.** Try to channel what you love about the animal as you draw it, and see if the way you work can reflect its key characteristics.

TIP *Remember there is no such thing as bad art. Enjoy the process of creating. The blank space can be intimidating so be confident, make any mark, and go for it!*

43

Think about interesting ways you can create animal patterns and **fill the pages with a patchwork of ideas.** Experiment with using cut or torn paper, blending colours and exploring a range of different art materials.

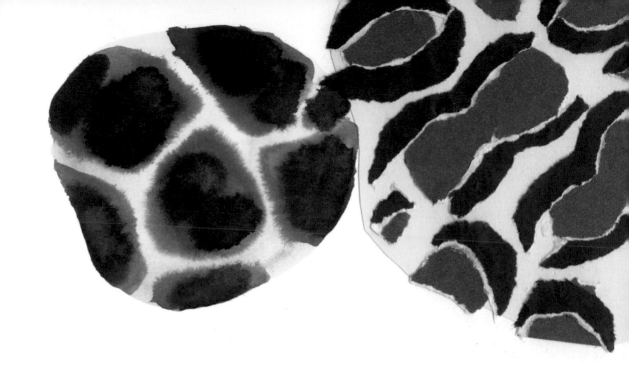

Draw the face of a big cat.

Consider the expression and
character of the animal.

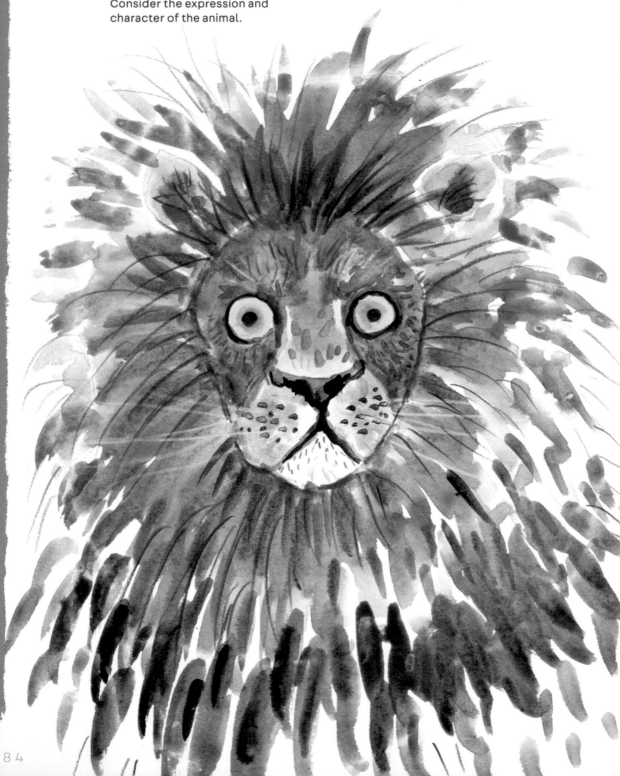

45

Practise creating the effect of elephant skin.

1. Add layers of watercolour paint in greys, dark blues and browns.

2. Before each layer of paint dries fully, lift some of it off with a scrunched-up piece of paper towel. Repeat this until it looks like leathery elephant skin.

3. Add tone and textural details once the paint has dried.

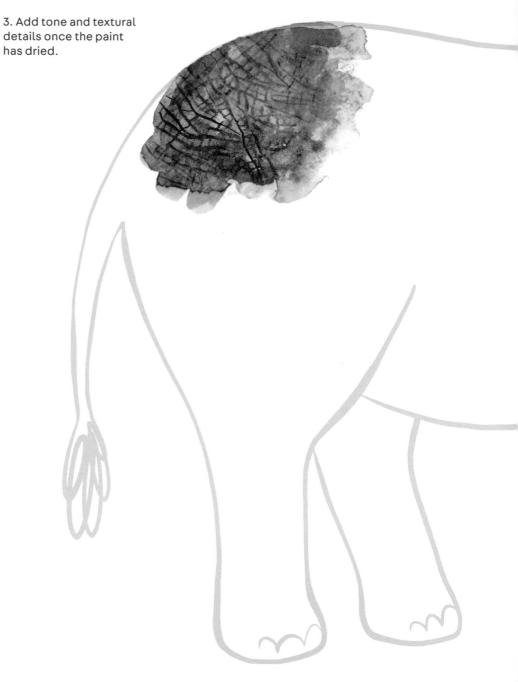

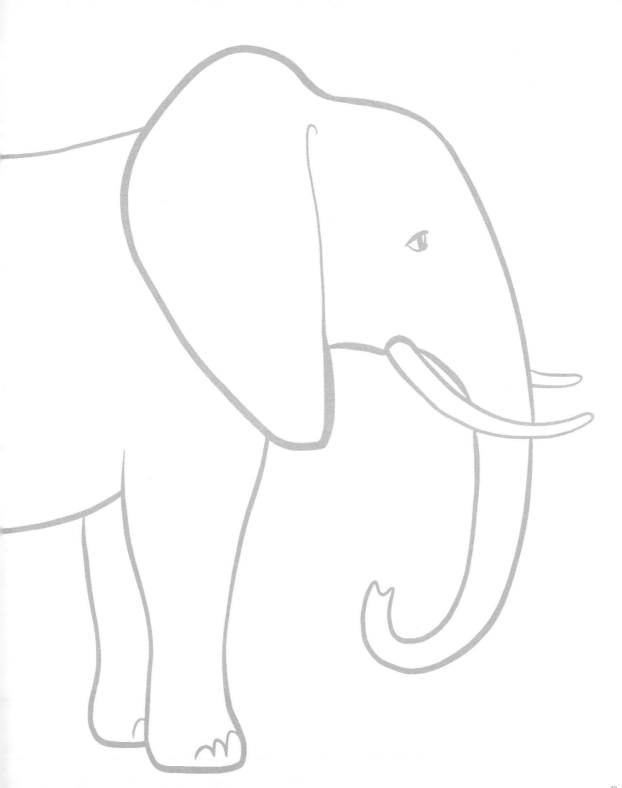

Draw an animal of your choice on a black background.
You could use acrylic paints, or try using oil pastels or
coloured pencils.

Use colours you wouldn't naturally choose, to create a vivid,
vibrant image that contrasts with the dark background.

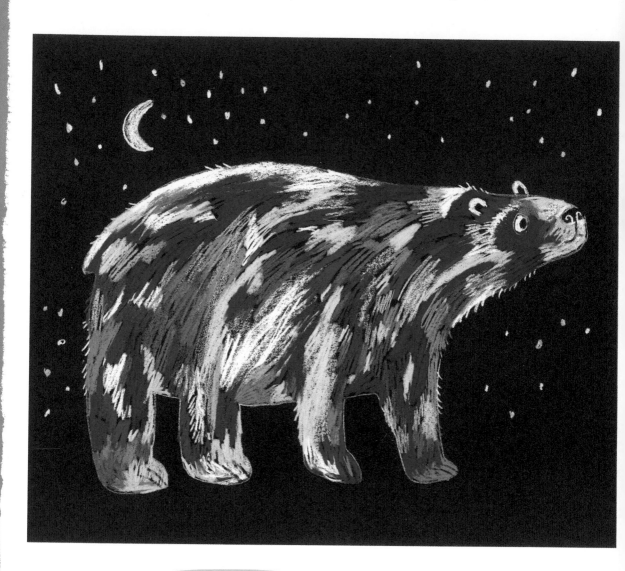

TIP *You could choose all the colours you'd like to use before
you begin. This means when you get started, you can focus on
enjoying creating your art, without having to think about picking
colours. Try to select from your palette instinctively, rather than
overthinking it.*

4 7 **Spend some time drawing foxes.** There are lots of approaches you could take; you could spend an hour creating a detailed sketch based on a photograph, and create a piece that is detailed and technically accurate. But you might think that your drawing feels a bit stale.

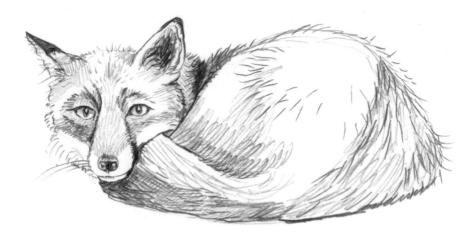

Of course, there is nothing wrong with that way of working. However, you could also try approaching the activity using a looser, more gestural style. You may find that this shows more movement and character. You could make a streak of orange across the page and start from there!

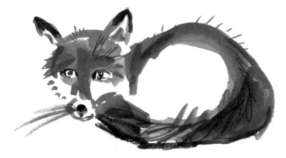

TIP *If you start by creating your art with energy and movement then it's likely your finished drawing will have them, too.*

If you choose to do a careful sketch first, then you can use what you've learned during the process to inform another, looser piece of art. For example, you may notice where the areas of interesting tone are, as well as the basic shapes of the animal.

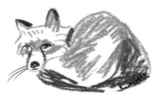

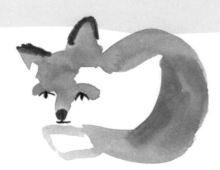

Create line drawings of lots of animals.
You could draw just the outlines, so you can concentrate on their shapes rather than tone and colour.

Use any materials you like, and don't worry if your drawings look wonky or inaccurate – it only adds to the personality of your art!

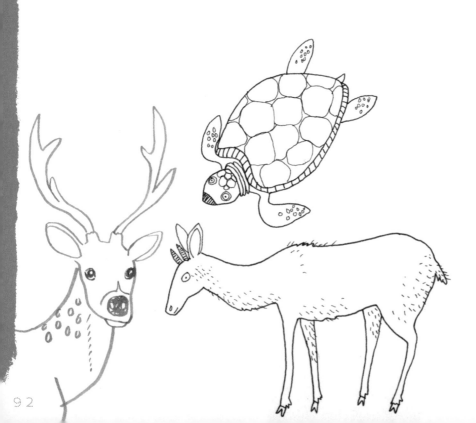

Use bold, expressive brush marks to create leopards.

Add features to the brush mark here to create a leopard, then add your own swoop of colour to the opposite page, to make your own big cat.

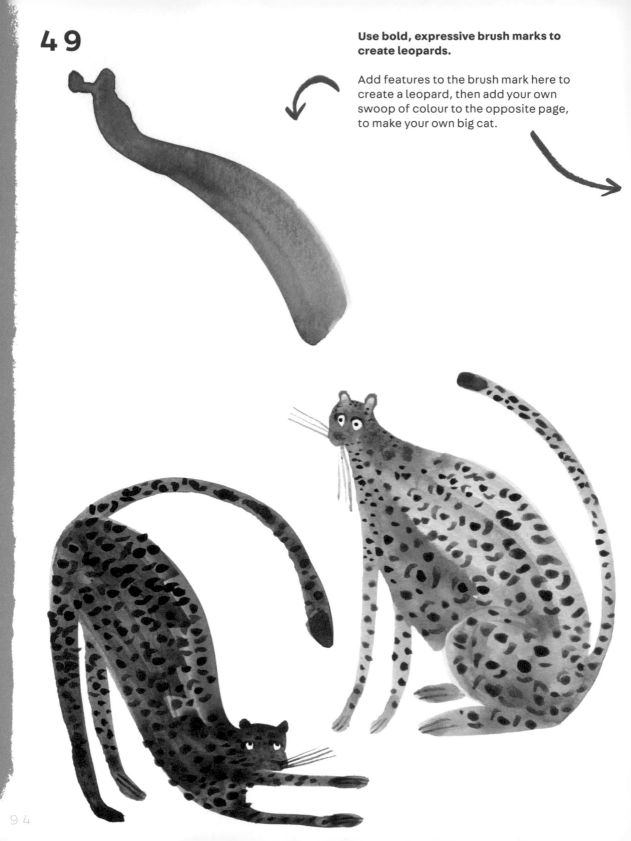

TIP *Tilting the brush so that it is on its side will give you a broader brushstroke – try tilting the brush as you move it.*

50

Draw a sloth hanging from a tree.
You could use pastels, and draw the fur using lots of different colours to help give the drawing life.

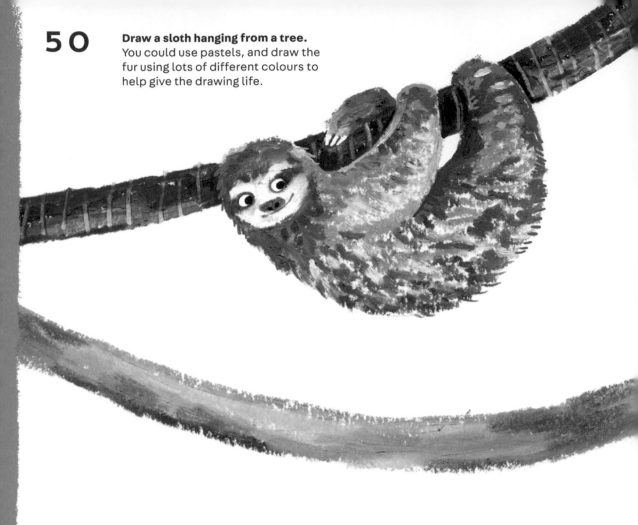

Design antlers for these deer and antelope.
They could look realistic, or you could make them fantastical.

TIP *You could make the antlers appear three-dimensional by adding shading.*

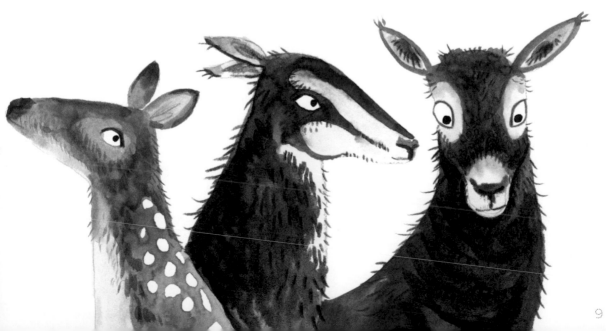

52 **Draw animals in their environment.** Adding backgrounds to your animal drawings means you are creating a world around them, which can help tell a story and add context to your art. Find an image of animals in an environment you like, or choose somewhere from life to observe animals. Draw what you see.

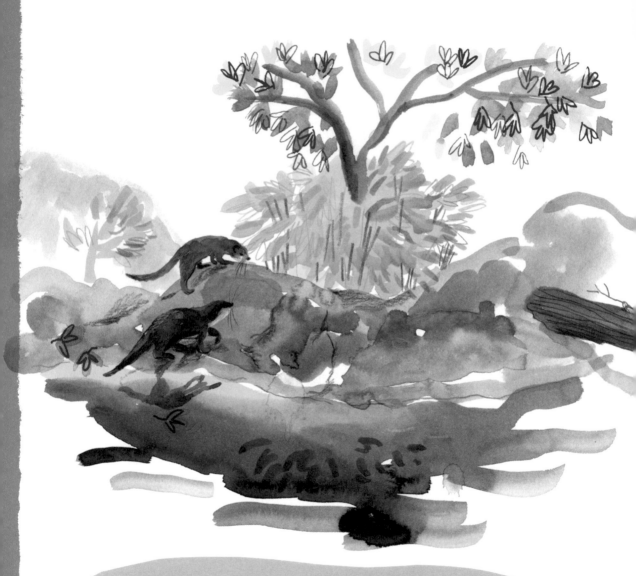

TIP *The good thing about drawing the landscape is that it is likely to stay still for longer than the animals! If drawing from life, spend time drawing the surroundings while the animals are on the move. Then, quickly draw the animals when they enter your scene, or take a photo of them to draw from later.*

Why not consider what mood an animal is in while you draw it? **Explore adding different facial expressions to these animals, to give them different moods.** Use all the features to help show how each animal is feeling – their eyebrows, eyes and mouths.

TIP *It can be helpful to make the expressions yourself while you draw, or to look in a mirror and notice which parts of your face change when you make certain expressions.*

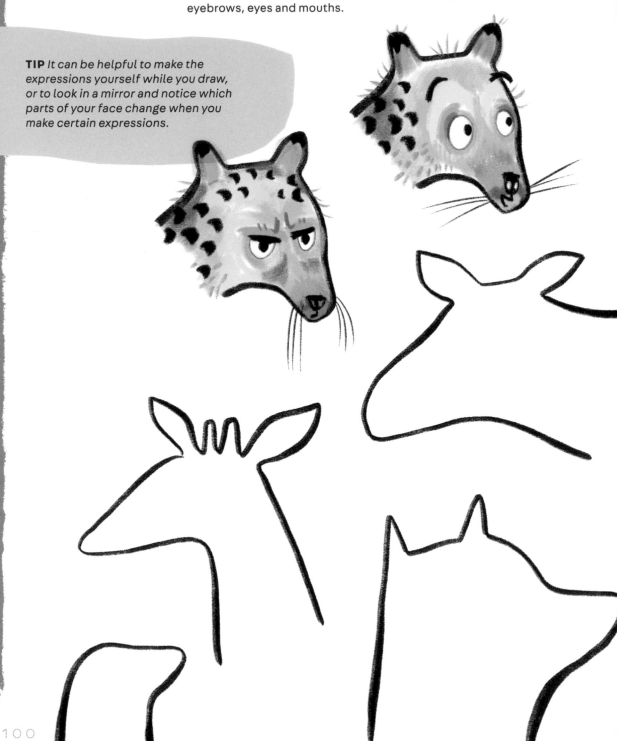

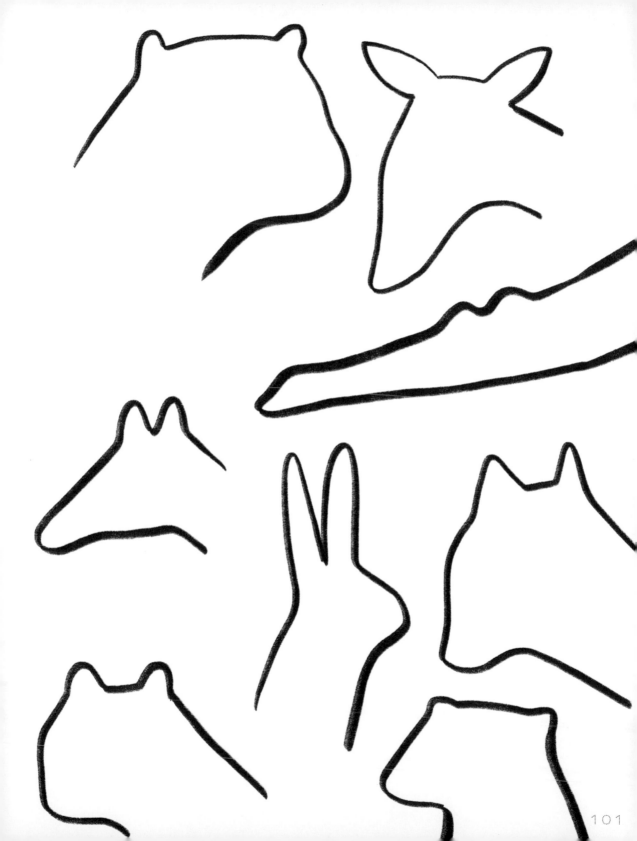

54

Draw a wild animal – either from life or from a photo – but leave part of your image incomplete.

There are lots of reasons to leave part of your drawing 'unfinished'. The eye fills in the blanks, so you don't actually need to draw every bit of detail that you see on the animal. In fact, leaving areas incomplete and loose can be really beautiful. It can help convey a certain mood – dreamy, relaxed or even something more energetic.

As soon as you feel content with the way your drawing is looking, it's time to stop. It seems a little counterintuitive, but a half-finished drawing can have more life than a finished one.

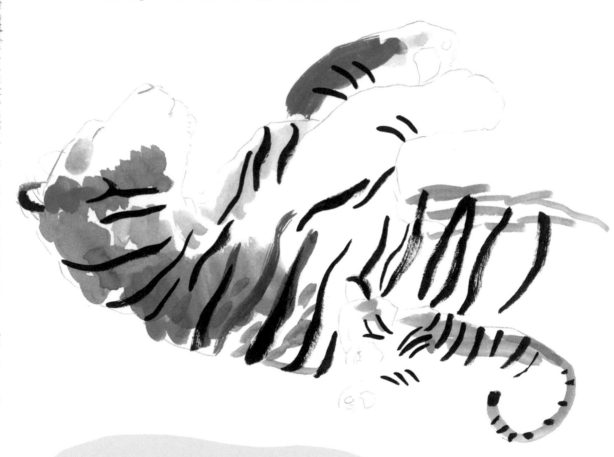

TIP *Have confidence when you add each line or mark to your drawing. Use one clear line to mark each element of the animal you'd like to show.*

Snakes have striking patterns and so make a great
subject for graphic pieces of art.

Create a bold design on this snake shape.
You could cut shapes out of coloured
paper and create a collaged pattern.

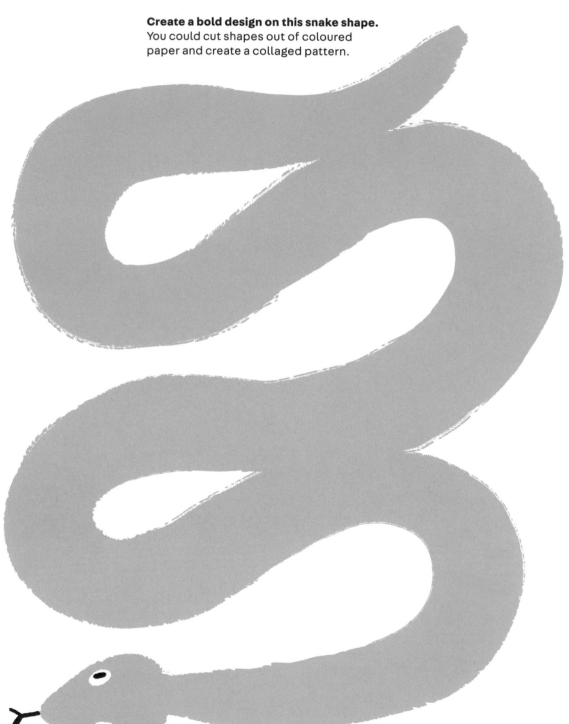

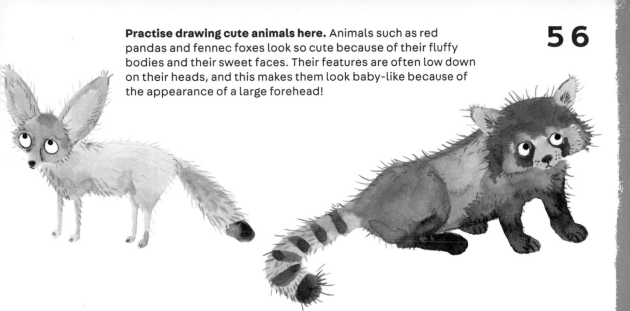

Practise drawing cute animals here. Animals such as red pandas and fennec foxes look so cute because of their fluffy bodies and their sweet faces. Their features are often low down on their heads, and this makes them look baby-like because of the appearance of a large forehead!

57 **Draw animals in motion.** Consider which materials can give a sense of fluidity and movement – you could try using a brush pen that can glide easily across the page.

Although it's not always easy to see wild animals running free, there are plenty of videos we can watch online, and photographs in books that capture the animals' movements.

TIP *Press pause on a video of an animal running and draw the leg positions you see. This can help us understand what goes where!*

TIP *Don't worry about accuracy, just focus on ways you can show movement. Perhaps add details quickly, as if they are flying off the body.*

TIP *You could also explore adding a blurred background to suggest the animal rushing through the environment.*

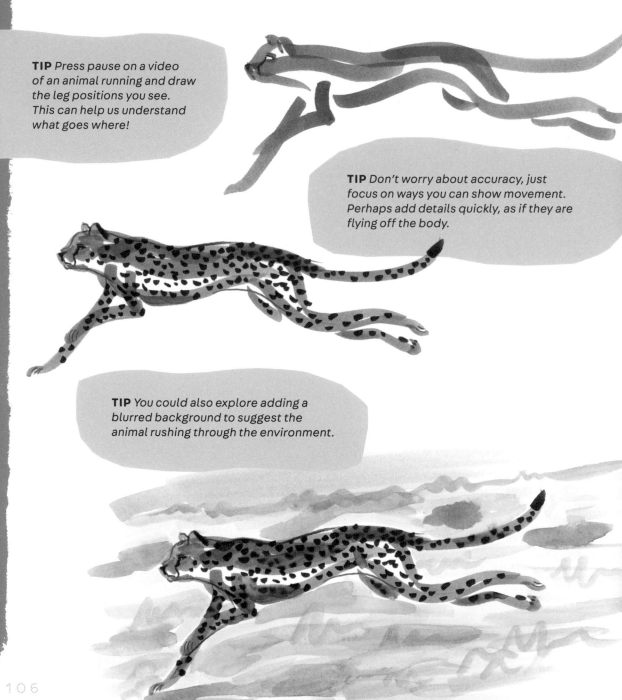

58

Add creatures to these simple landscapes and then draw your own landscape backgrounds for animals. You could use acrylic paint or collage to create your animals, as these give good coverage and will stand out well against the backgrounds.

TIP *It can be useful to consider the scale of your animal – what size would it need to be to make sense in these environments?*

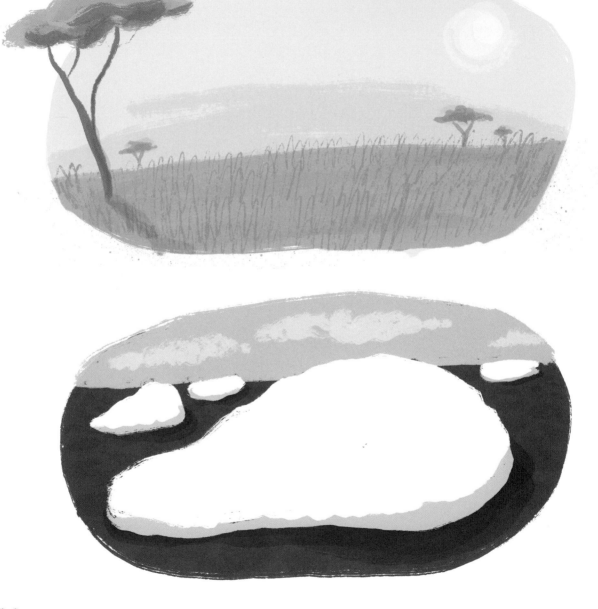

Enjoy recreating textures found in the animal kingdom.
Draw scales, fur and skin in a variety of colours and art materials. Think about how you could represent each texture, perhaps using patterns, bold repeated shapes, blended colours and mark-making.

TIP *If you don't have the exact coloured paper you'd like for a collage, you could paint blank sheets of paper in any colour, and cut them up once they are dry.*

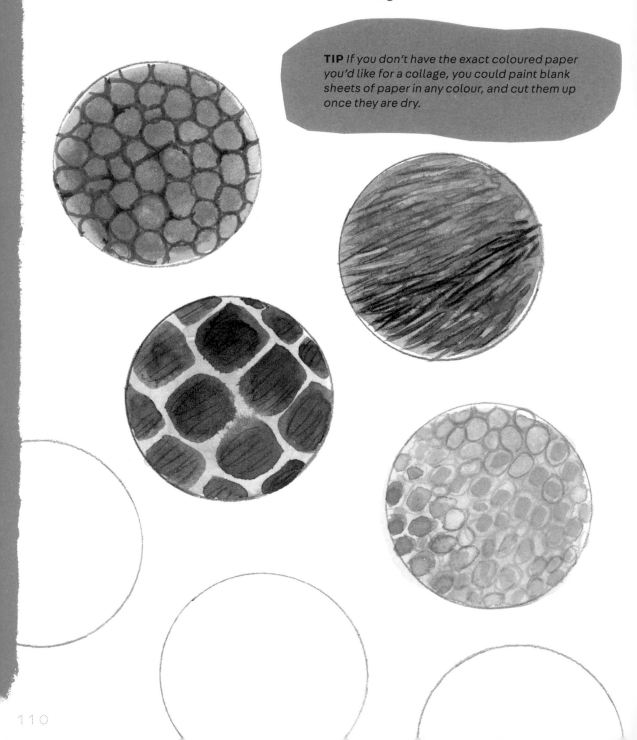

60

Draw as many animals as you can think of, without looking at the page!
Try to draw in a continuous line – without lifting your pen from the paper.

Once you've drawn the outlines, look at what
you've created and add features such as eyes
and noses, and perhaps some colour too.

The aim is to totally let go, and fill the
whole page with your art.

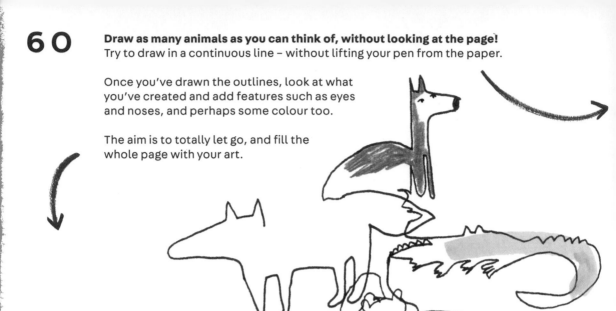

TIP *This is really tricky, and you may find you need to look
at the page a lot to start with. Remember to embrace the
mistakes and enjoy the silliness of your creations!*

61

Create an animal or group of animals out of collaged paper.
Cut or tear bold shapes to make the forms. Perhaps you add
details with small bits of cut paper, or with a pen or pencil.

TIP *Drawing with paper may be outside your comfort
zone, but it's a great way to make art! You could
position your paper first, then glue it down when you
are happy with your composition.*

There is no such thing as 'bad' art, and here you can embrace the quirks of how you draw.

Draw lots of deliberately wonky, out-of-proportion, lumpy, not-quite-right animals and just have fun with it! Enjoy the freedom of drawing in any style you like without feeling any pressure to create something that looks 'perfect'.

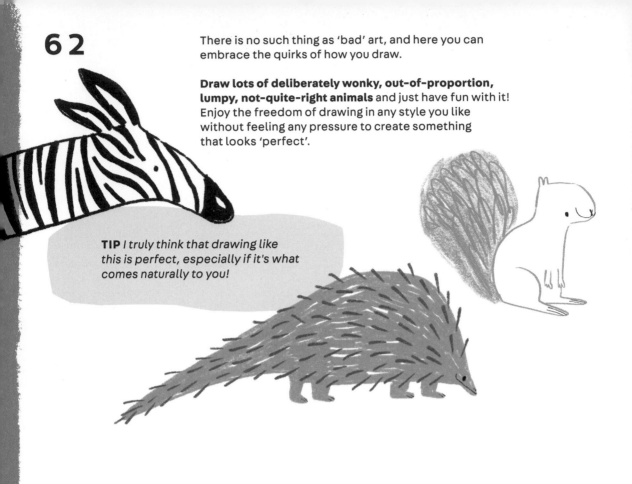

TIP *I truly think that drawing like this is perfect, especially if it's what comes naturally to you!*

6 3

You may feel that some animals exhibit really strong personality traits, and it can be fun to show that character in your drawings. **Choose an animal with a strong personality and draw it, paying particular attention to how you can show its character.**

TIP *Think how the body and face of a human might look when they are showing certain personality traits or moods. Your animal could be doing the same!*

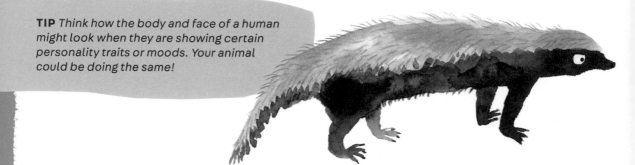

Dark backgrounds can be a good way to create a piece of art with atmosphere or if you want to make a night-time scene. **Draw wolves howling here, using white and grey pencils, oil pastels or paint.**

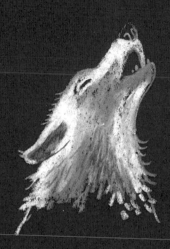

6 5

Draw animals from life, in their natural habitats.
Perhaps you could visit your local park, or maybe
there are wild animals where you live, or that you've
encountered in your travels.

If animals feel comfortable with you being there, and
you respect their space, you can get a really good
sense of their habits and personalities.

Before you start drawing, take time to observe the
animals. How do they move? What shapes are their
bodies? What colour are they, really?

When you've got a better understanding of them, start
drawing in any materials you like. You may want to
explore different ways of working depending on what
you feel inspired by. Perhaps consider what you enjoy
most about the animals and start by drawing that.

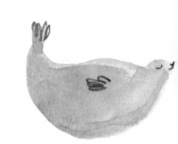

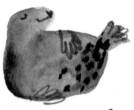

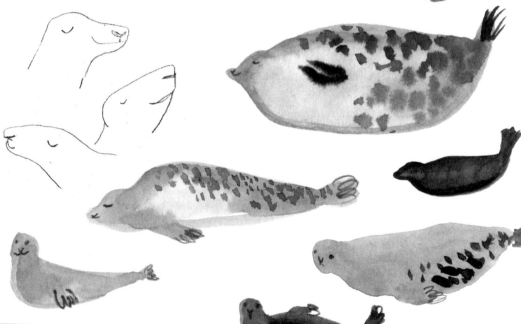

TIP *Once you've made your sketches,
you could take your art further. Consider
creating a painting or models based on
your drawings.*

66

Create an image using tiny drawings of animals. Think about the simplest way you can draw them.

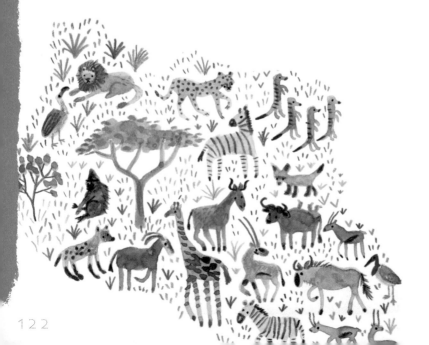

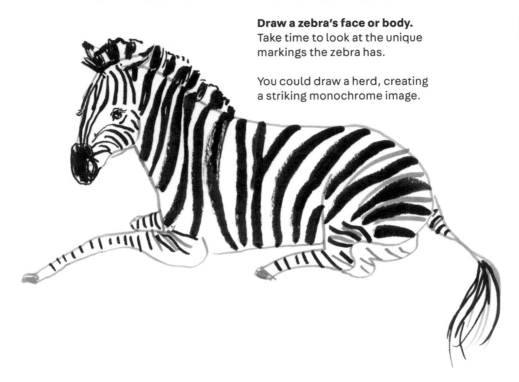

Draw a zebra's face or body.
Take time to look at the unique
markings the zebra has.

You could draw a herd, creating
a striking monochrome image.

Add colour and pattern to these animals. Go with whatever style and materials you feel like – they could be completely imagined markings.

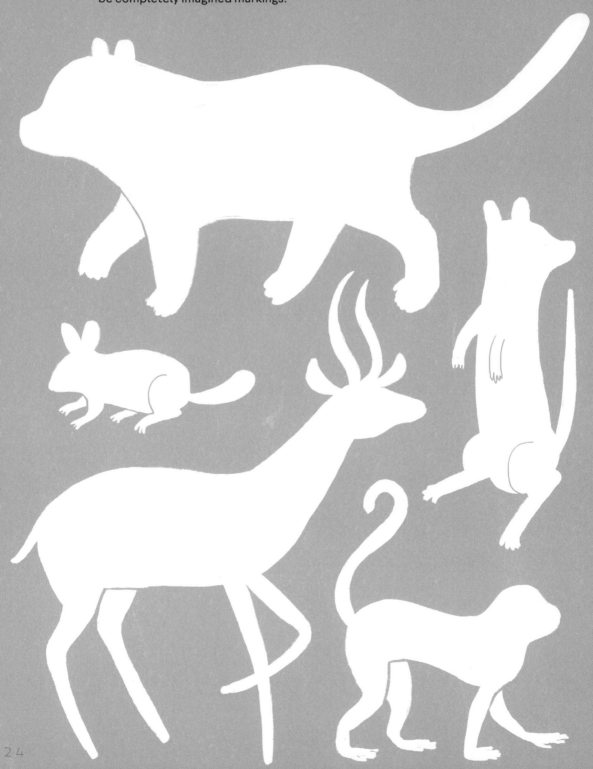

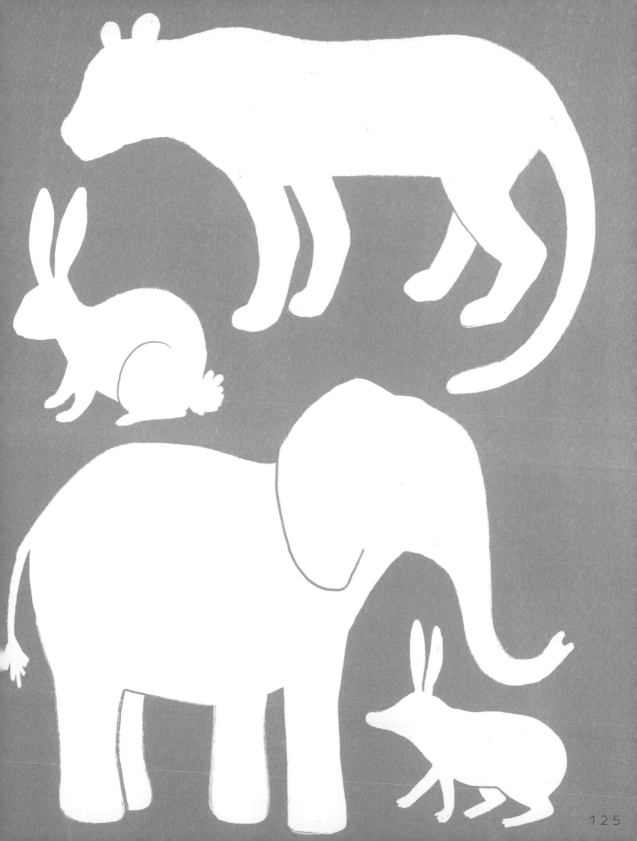

One way to draw animals as they move about is by viewing live webcam streams provided by zoos, animal reserves and national parks.

Search online for an animal you'd like to observe and draw it. You could make sketches from observation, gathering as much information about your subject as you can in your drawing, and then create a more sustained piece of art based on these.

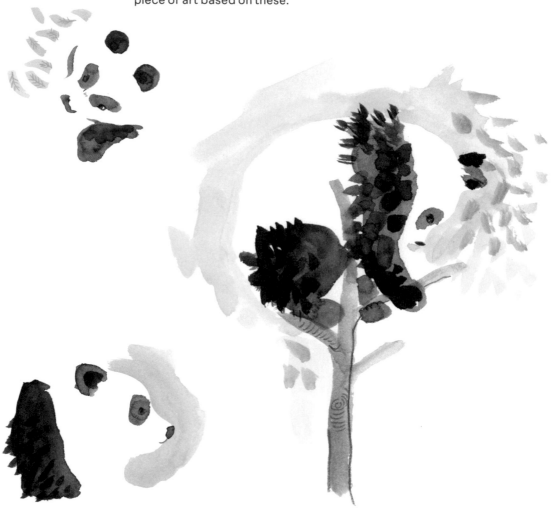

TIP *You may need to try a few different videos to find an animal who is keeping still for long enough to draw! Or, you could pause the video when they are in a pose you'd like to capture.*

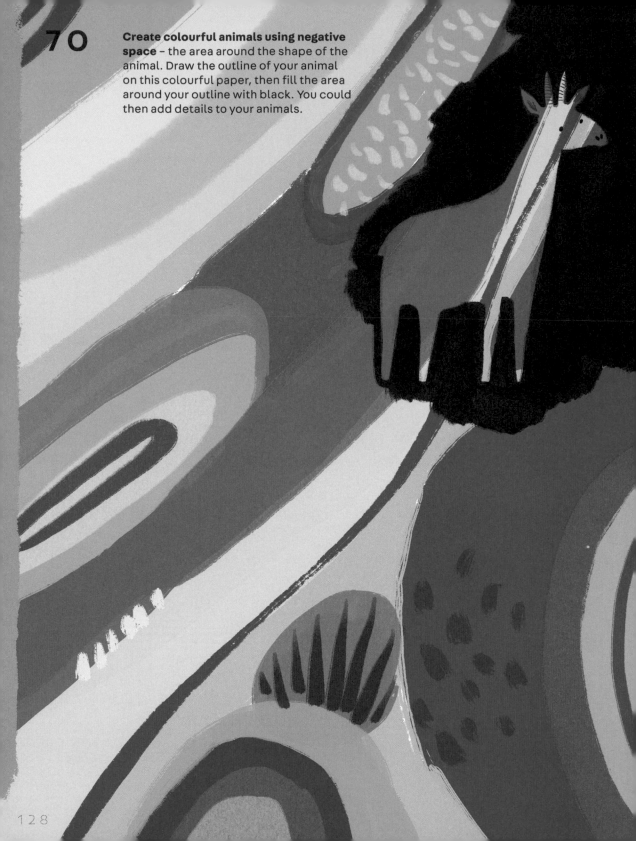

70 **Create colourful animals using negative space** – the area around the shape of the animal. Draw the outline of your animal on this colourful paper, then fill the area around your outline with black. You could then add details to your animals.

Draw monkeys hanging from the branches by their tails, arms and legs! Consider different poses they could be in.

TIP *You could mark out the body and limbs roughly using pencil lines, before adding more detail.*

Draw an underground burrow for this badger.
Show the cross-section of the soil, and the passages connecting
larger holes. Perhaps there are other animals underground too.

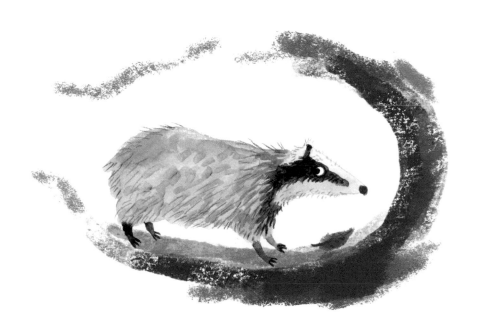

BIRDS

As a warm-up, make quick drawings of flying birds. Keep it simple.

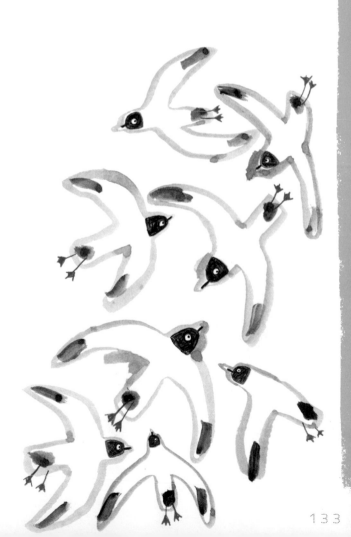

74 **Explore the different shapes of birds,** drawing as many as you can think of.

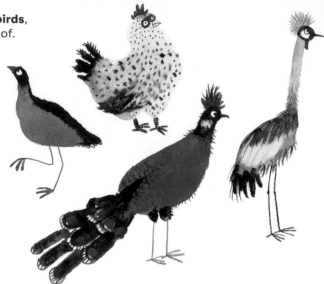

There is so much variety in the plumage of bird life. **Add colours and patterns to these shapes to create beautiful birds.**

76

Create a flock of parrots and parakeets from this colour profusion.
Look at pictures of tropical birds and draw them into this scene, using the background colours as starting points for their feathers. You could add more of your own colours too.

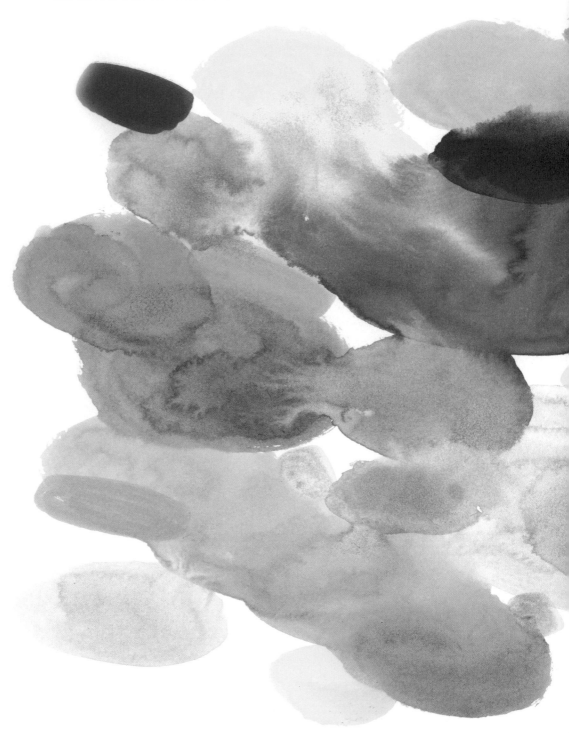

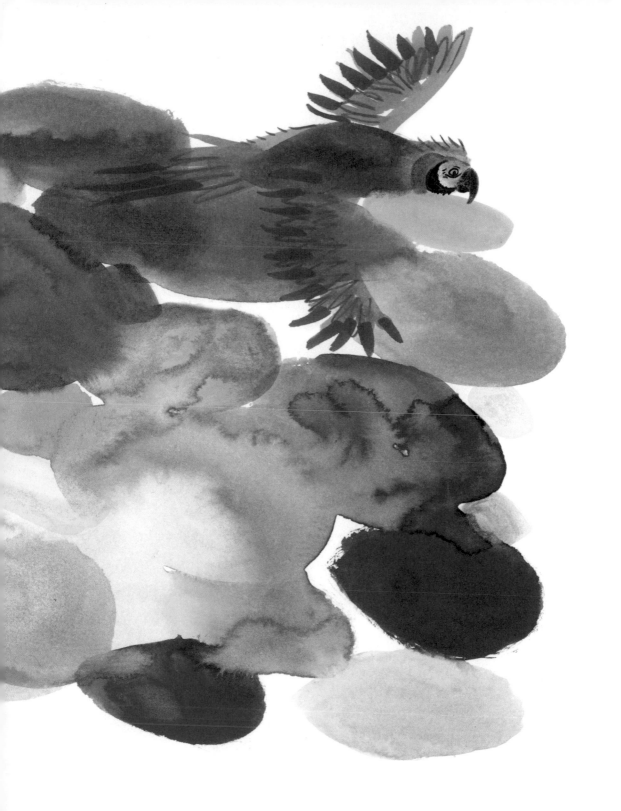

77

Use negative space to create a piece of art based on a bird.

Drawing the space around a bird first is especially useful with those that have light areas on their bodies, such as penguins. You can avoid using an outline, and draw using blocks of colour instead.

Try this with a seagull, snowy owl or penguin.

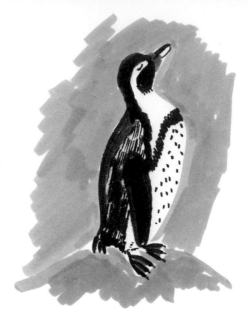

Fill the page with birds in flight, paying attention to the variety of shapes their wings make as they fly.

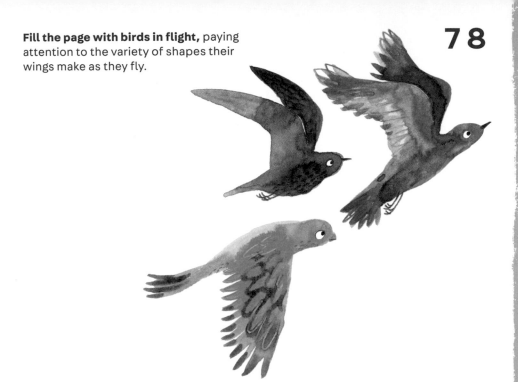

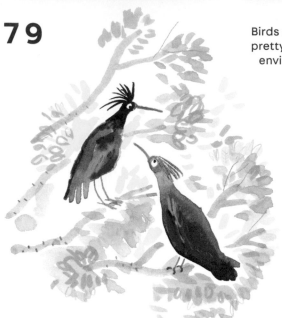

Birds make great subjects as we can find them pretty much anywhere. Show them in their environments to give context to your art.

Paint and draw birds in different environments – consider seabirds, jungle birds, garden birds. Perhaps draw them in different nests too.

TIP *You don't need to add loads of detail to suggest their surroundings, perhaps just the branch that they are on, or a bit of the ground or sky.*

80

Create your own birds of paradise.

You could explore different materials, perhaps using cut paper to make collages with bright colours. Consider drawing patterns on the birds, long tail feathers or unusual beaks.

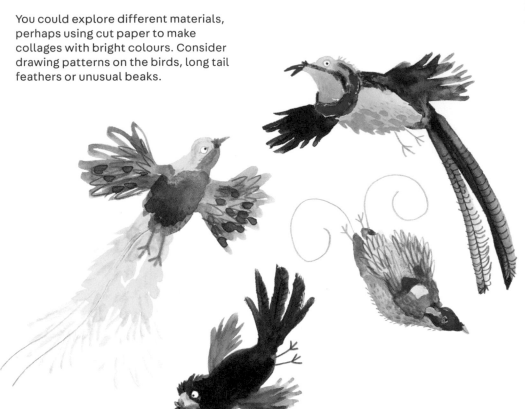

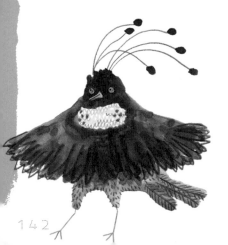

Draw penguins using any material you like. You could use brush-tip pens, drawing a rough shape first in light grey. Then you can add in the form more confidently, using vibrant colours and bold marks.

Look at videos of penguins and notice how they move, then try to capture this movement in your drawings.

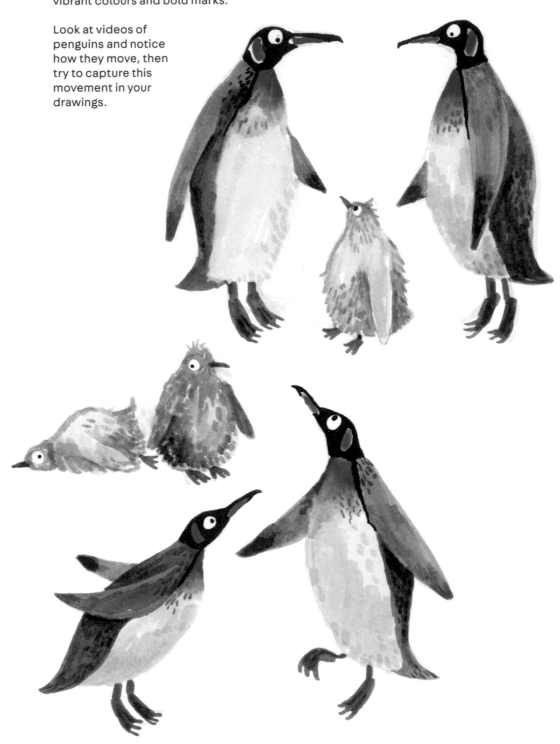

Finish off this painting of a pair of lovebirds on a branch.
Concentrate on adding lots of vivid colour, and practise
drawing feathers.

You could use paint to create the general shape of each feather
– with each brushstroke representing one feather. You can then add
details using a fine coloured pencil or pen.

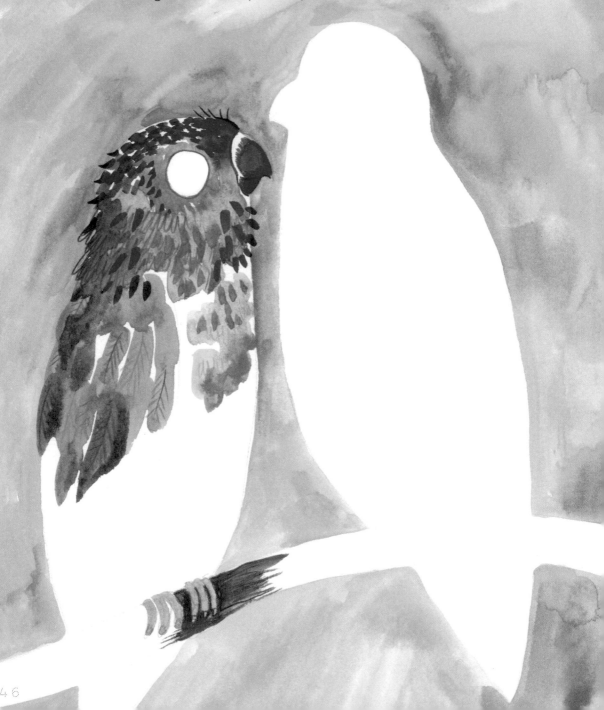

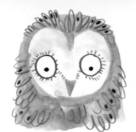

Create some owl characters.
Owls have really expressive
faces because of their big eyes.

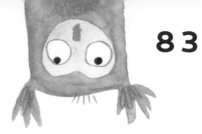

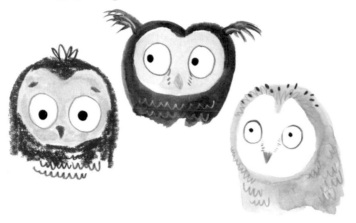

Draw a collection of birds.

It can be relaxing to draw lots of birds together, rather than focusing on just one. You may feel there is less pressure to get it *right* first time, even though there really is no such thing as *wrong* art!

A group offers a chance to explore different poses, colour variations and shapes, as well as consider the design and composition of your page, and how all the animals look together.

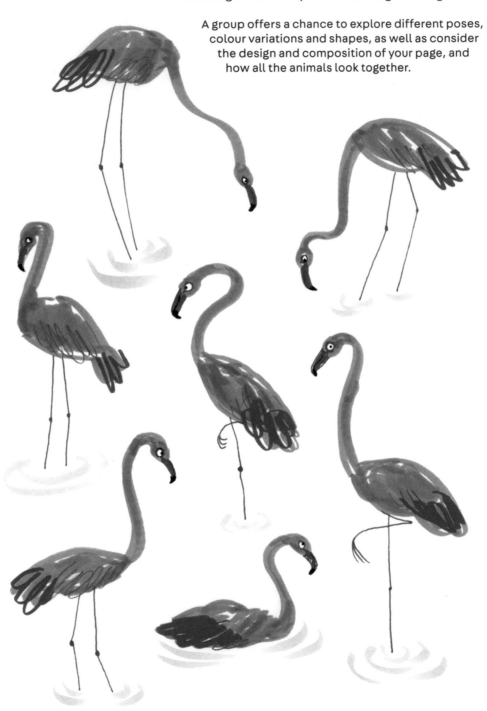

85

Take your drawings off the page, and make a three-dimensional model of a bird.

Start by drawing simple sketches of birds, until you find a shape that you think might work well as a little sculpture. You may want to draw your bird from many angles, to act as a guide when you are making your model.

You could make your bird out of anything you like – papier-mâché, air-dry clay, bits of card or fabric.

TIP *They could be very little!*

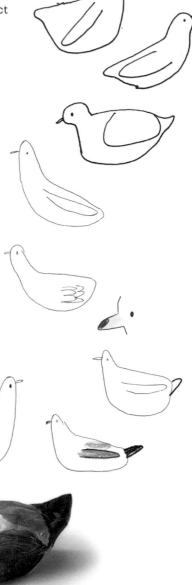

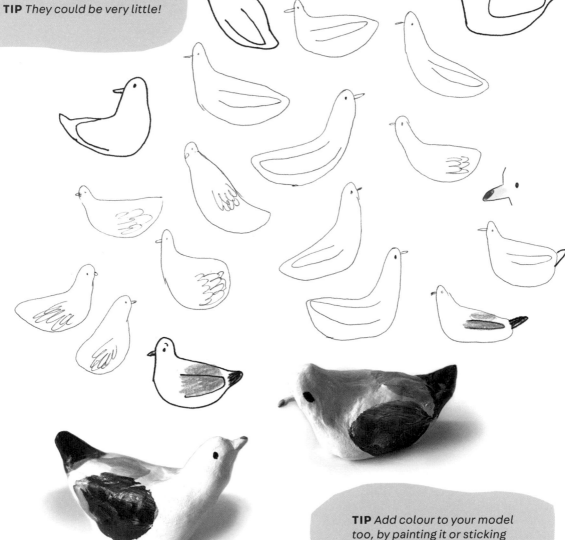

TIP *Add colour to your model too, by painting it or sticking coloured paper onto it.*

MINIBEASTS

Warm up by drawing lots of insects in this scene. You could make them all in line drawings or add colour if you like.

8 6

Paint the other side of this moth.
It doesn't need to be perfectly symmetrical – just enjoy creating the colours and patterns.

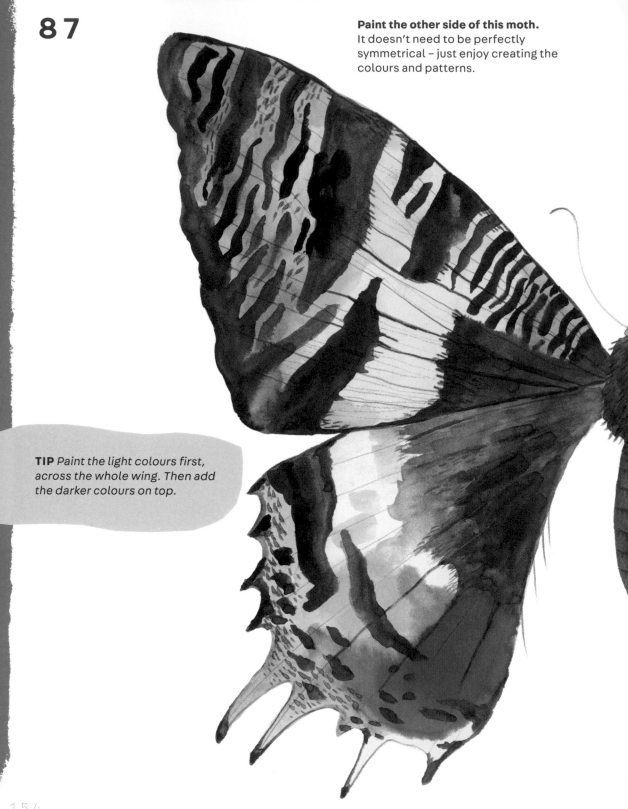

TIP *Paint the light colours first, across the whole wing. Then add the darker colours on top.*

88

Fill the page with flowers and bees.

There are lots of different types of bees, and you could draw a few varieties. Include flowers in your image, too.

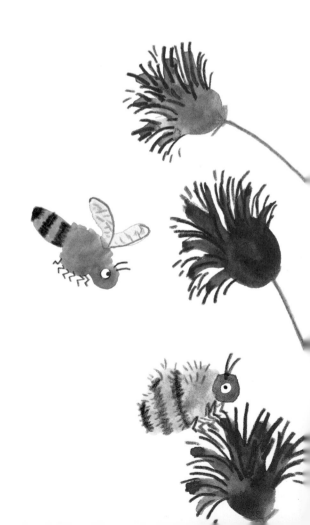

Beetles come in so many different shapes, sizes and colours.

Create your own beetle designs, from life or from imagination.

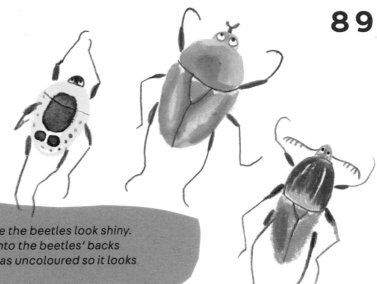

TIP *Consider how you can make the beetles look shiny. Perhaps you add a white line onto the beetles' backs using pastel, or leave some areas uncoloured so it looks as if they are reflecting light.*

Continue the collage to create ladybirds,
or use any other art material you like.

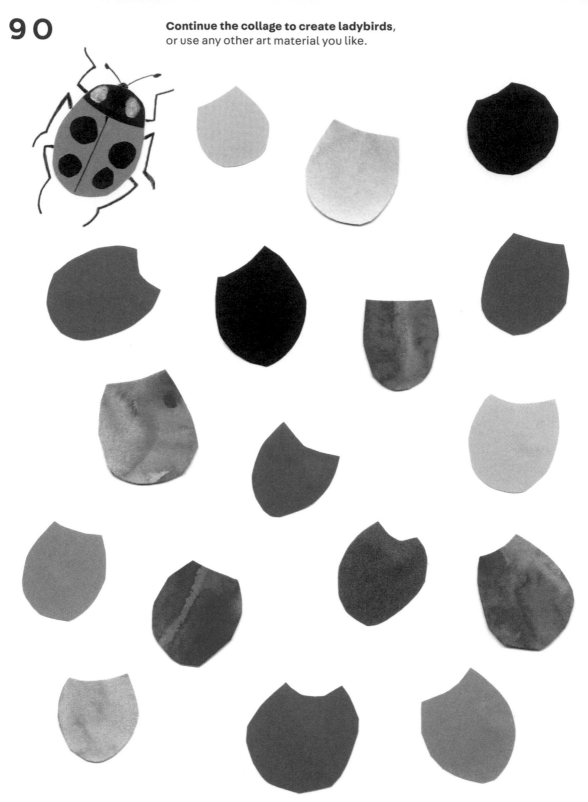

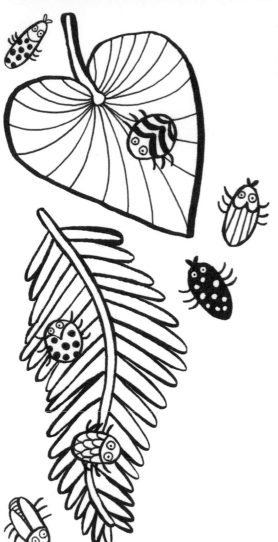

You can create simple yet striking patterns using black lines on a white background. **Draw bugs and bold leaf shapes, to create a graphic pattern.**

Enjoy drawing the outline of a minibeast rather than adding lots of colour and tone.

There is often a lot of detail to capture in small insects. Use paint or an ink pen to create your drawing. You could draw a beetle, caterpillar, ant or spider.

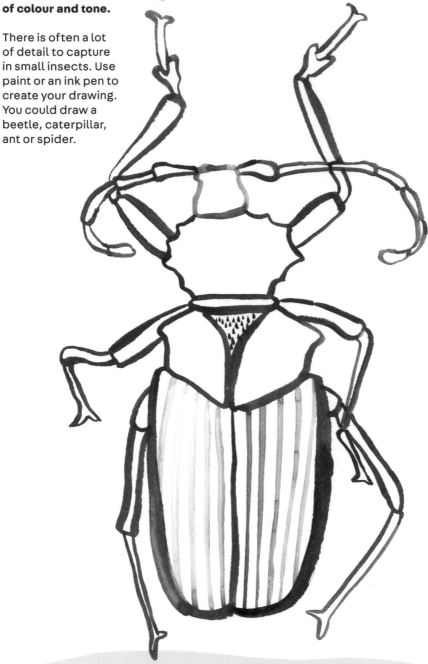

TIP *Your line most likely won't be perfectly even, and that's great! Everyone has their own unique line, and it's this that gives art personality and character.*

93

Paint butterflies. You could use the outlines given, and focus on the colours and patterns, or add your own.

If you can, draw the butterflies from life, or you can use your imagination, or look at photos to discover vivid, exciting patterns.

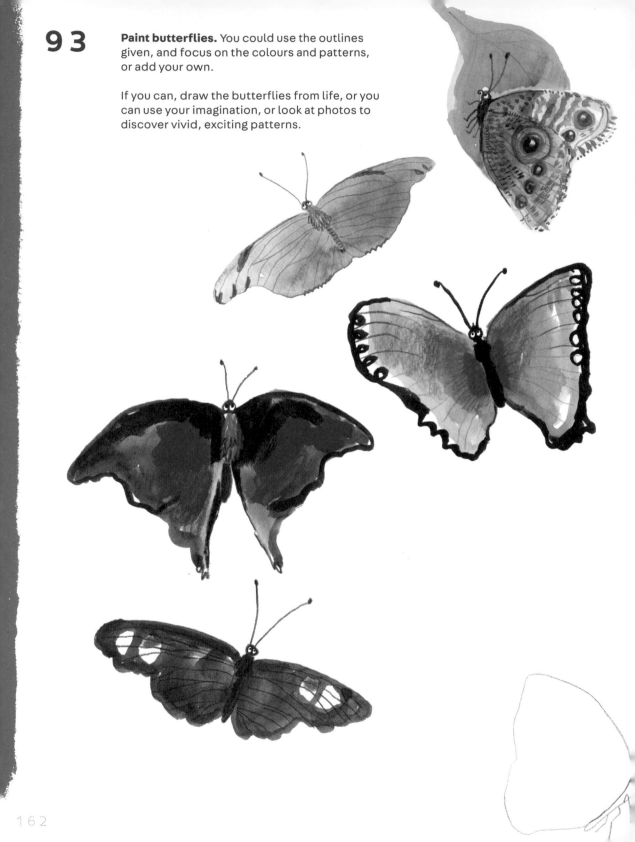

FANTASTICAL

Warm up by combining these animals – a pangolin and a narwhal – to create a fantastical creature.

You could use the scales from the pangolin and the horn from the narwhal, and even add in parts from other animals too, if you like. The more ridiculous, the better!

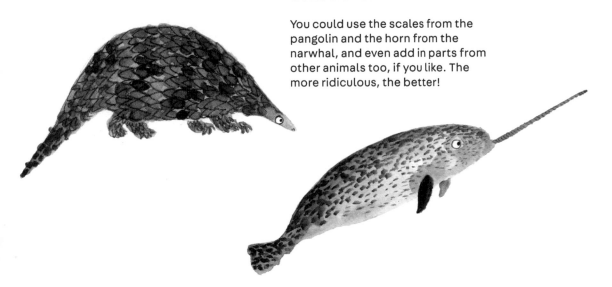

Colour this unicorn in using rainbow shades. You could blend colours together to help make the creature look magical. Perhaps add a rainbow background, too.

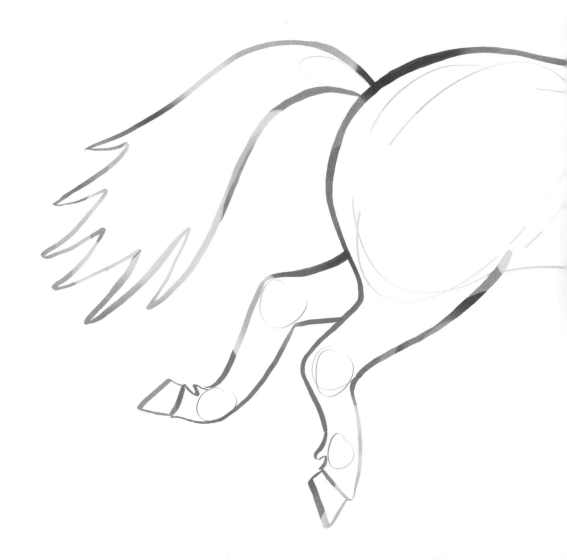

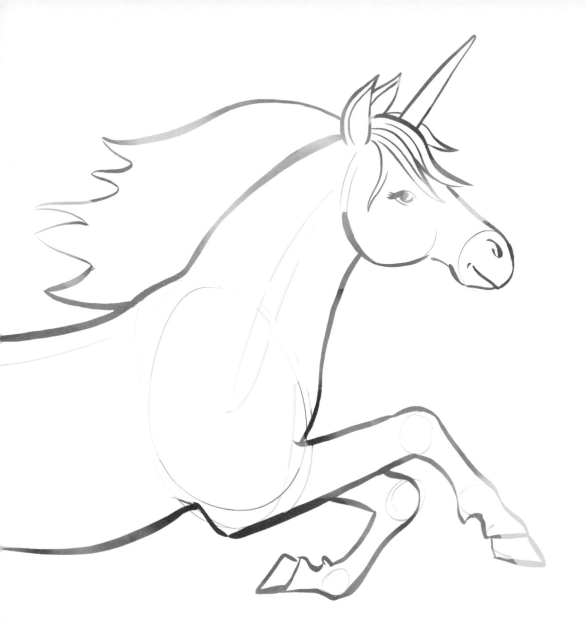

Create an animal from three different creatures. In the central section, draw the middle of an animal – real or imaginary. Draw the neck slightly over the dashed line. Then, draw the head of your animal.

TIP *You can also create animals with other people. Each person takes it in turn to draw a different part of the animal and then hides what they've done before the next person draws.*

Design imaginary animals for these horns.

If there are horns that don't fit with your design, cover them with paint, or perhaps incorporate them into a scene around your animals.

99

Let your imagination go completely wild and draw a dragon!
Does it have scales or smooth skin? Talons? Spines? Wings?
Consider how you could create different textures on your dragon's body.

TIP *Draw your dragon out roughly first using a light pencil and remember, there is no right and wrong with art!*

Design fantastical creatures inspired by the splodges below. You may want to add more colours and shapes.

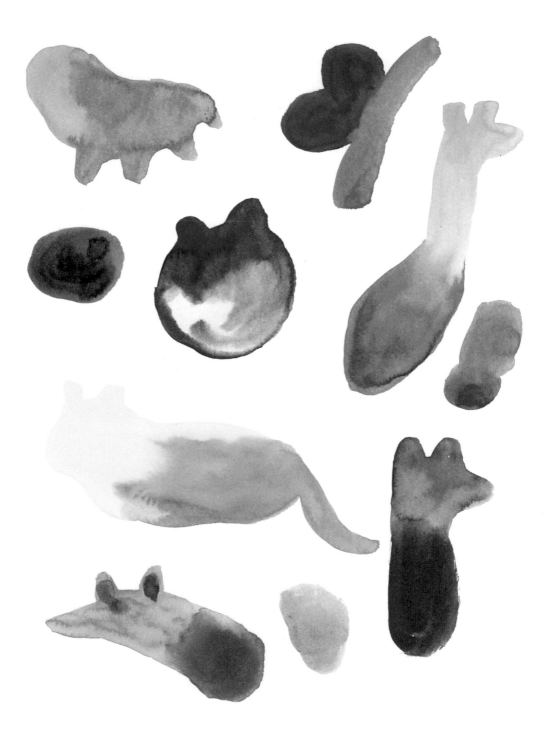

**Draw the rest of these creatures
to create a new animal.**

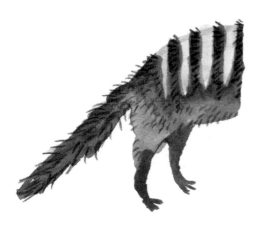

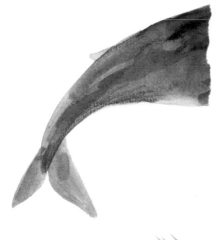

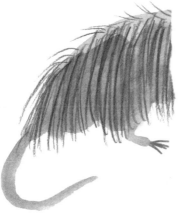

Animal Art: 101 Creative activities to inspire and guide you

Published in 2023 by Hardie Grant Books,
an imprint of Hardie Grant Publishing
Hardie Grant Books (London)
5th & 6th Floors
52–54 Southwark Street
London SE1 1UN

Hardie Grant Books (Melbourne)
Building 1, 658 Church Street
Richmond, Victoria 3121
hardiegrantbooks.com

British Library Cataloguing-in-Publication Data. A catalogue record for this book is available from the British Library.

ISBN: 978-1-78488-445-1

Publishing Director: Kajal Mistry
Acting Publishing Director: Emma Hopkin
Senior Editor: Chelsea Edwards
Proofreader: Clare Double
Concept Designer: Mylène Mozas
Senior Production Controller: Katie Jarvis

Colour Reproduction by p2d
Printed and bound in China
by Leo Paper Products Ltd

10 9 8 7 6 5 4 3 2 1

FSC
www.fsc.org

MIX
Paper | Supporting
responsible forestry
FSC™ C020056